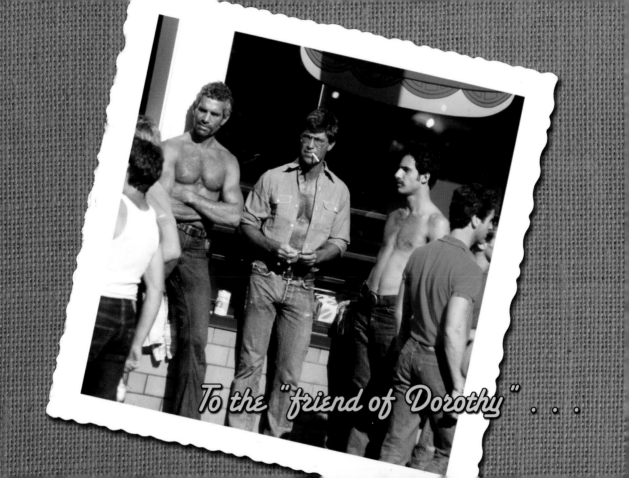

To the "friend of Dorothy" . . .

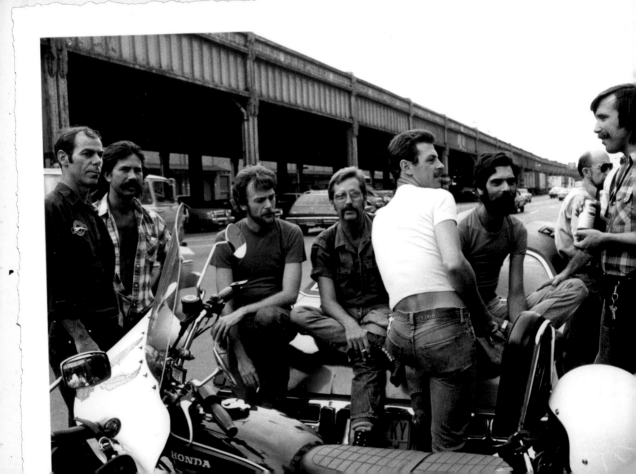

Greetings

FROM THE

GAYBORHOOD

*A Nostalgic Look
at Gay Neighborhoods*

Written and designed by **DONALD F. REUTER**

ABRAMS IMAGE, NEW YORK

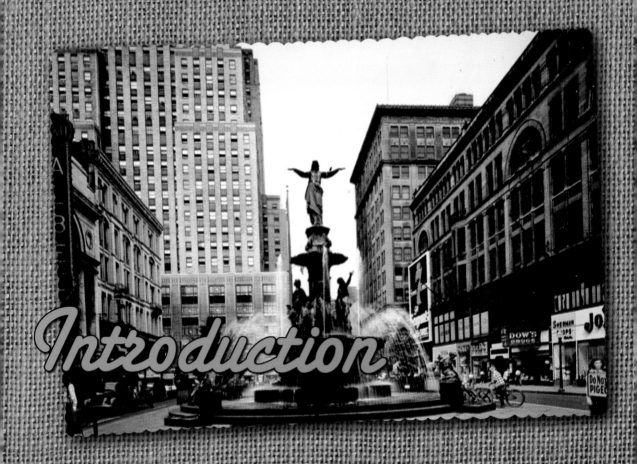

Introduction

Gay + neighborhood = gayborhood: that urban area where we gay people are—or appear to be—the majority of visitors and residents. But that's hardly the whole story. These enclaves represent social factors—economic, political, moral, and geographical—that came together in a unique way a few generations ago so that we could "come out." But their existence appears destined for Camelotian spans, as those same forces now seem to be pulling gayborhoods apart. *Greetings*, with its whirlwind tour of twelve gayborhoods, through brief historical jottings and scrapbooking of rare mementos, was conjured to signify their ephemeral natures, reflective of the same elusive quality of its inhabitants. So fasten your seat belts, boys—and enjoy the ride.

FROM HOMETOWNS TO BOYSTOWNS

There is no denying this is a good time to be gay. But the experience is not the same everywhere. Nor does every city have a gayborhood, including my hometown, classically conservative Cincinnati—a spot where those of a "bent"

persuasion often find it necessary to leave for places with people similarly *inclined*. I was one of them, and my experience—leaving my hometown to find what felt more like home—is quite a common thread among gayborhood residents.

So I fled to Manhattan. But when I arrived, "the scene" was in flux: Greenwich Village was "historic" (thus slightly passé, as per our sensibilities); queerness on the Upper West and East sides or Midtowns East and West was waning; and the *fey*-rocity of Chelsea and the East Village had not settled down, but soon would.

HOMOSEXUAL IN THE CITY

Whether we actually live in one or not, gayborhoods were and are where we all come to celebrate, be thoughtful, and seek refuge from a society largely uninterested in satisfying our "special interests."

Ironically, three American cultural features were greatly responsible for the birth of gayborhoods.

The Adult Nature of Cities

Though the degree to which this is true varies, cities are

where one expects to find things that are of interest to adults—and to have more blue vs. red-state-of-minders, higher learning institutions, and close quarters (concealing what is harder to hide in the open hinterlands).

The Great Middle-Class (White and Straight) Flight to Suburbia
This mid-twentieth-century population movement, by nearly emptying every notably sized city's core, essentially set in motion the emergence of gayborhoods. Apparently what was unsuitable space for raising postwar families was fine for those with little choice: poor, ethnic minorities and equally financially challenged (and frequently sexually ambiguous) single males.

Male Privilege
Speaking of men—we were (and still are) regarded as able to make it through difficult situations successfully. So the preponderence of guys comingling in harsh inner-city environments, particularly postwar, led to their laying the seeds for especially male gay communities to grow.

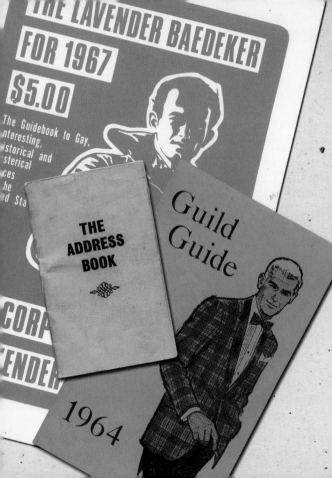

As a consequence of this threesome, the following six periods of specific gayborhood growth emerged.

That's Entertainment (1946 to 1958)
Nearly every American city had established "pleasure" spots/zones where visitors, particularly guys, could have fun at any hour of the day. Sometimes this came in the form of entertainment where part of the show was the mystery of the sex of the sexy entertainers. For some it was a steam at the local YMCA. For others, it was drinking at a "men's only" hotel bar, where many harried-married, commuter, and/or out-of-town businessmen passed the time quite amiably alongside gents not so tethered.

Present, but Unseen (1959 to 1968)
This was a period of realization that the status quo was not for everyone, and when we began to self-identify and claim territory for our own. But our existence was still largely invisible and this time served mainly as a softly played overture hinting at the loudly heraldic period that would follow.

The Golden Age (1969 to 1978)

The incident at Greenwich Village's Stonewall Inn was just one moment in gay history. But undeniably after June 1969, there was a significant rise in our visibility, especially in neighborhoods now considered quintessentially gay and of the "golden age." What made them so? Their aura of unabashed homosexuality. Curiously enough, these areas would never have become so "that way" if not for their economic viability and geographic accessibility (by subway, bus, or foot). Though we can live anywhere, lengthy travel to a safe haven exposes us to a vulnerable—often fearful—state of mind and body. Therefore, an easily reached home became a place where security and strength could quickly be found.

The Poster Boy (1979 to 1988)

By definition, golden ages don't last forever. But warn-

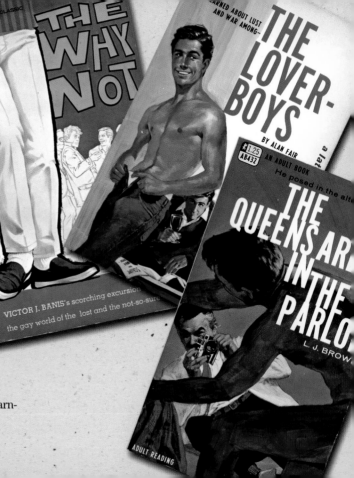

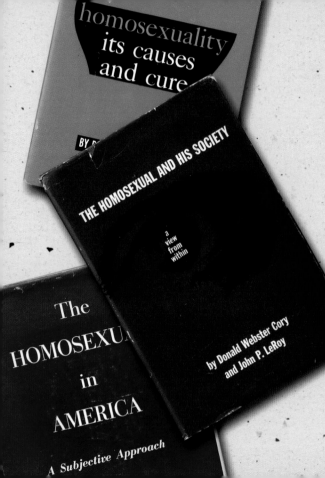

ings of an end came swiftly (and with little subtlety): The "Disco Sucks" rally in Chicago's Comiskey Park; San Francisco's Harvey Milk being assassinated along with Mayor George Moscone; Jerry Falwell forming the Moral Majority; and conservative Ronald Reagan's defeat of sitting liberal Jimmy Carter for the presidency. The most devastating blow: the appearance of GRID (AIDS) and HIV.

This resulted in a "cleansing" of our promiscuous ways, allowing us to become "poster boys" described as "just like you" and the innocent opposites of preceding impure "daddies." Simultaneously, "older" '70s gayborhoods like New York City's Greenwich Village and Los Angeles's Silverlake yielded to the "younger" '80s environs of Chelsea, West Hollywood, and Chicago's Lakeview, also known as *Boys*town.

Gay Is Good (1989 to 1998)

By now, gayborhoods had became the neutered shells of their former sexier selves and harder to distinguish from other spots around town. Additionally, the stigma of HIV and AIDS was lessening, allowing more

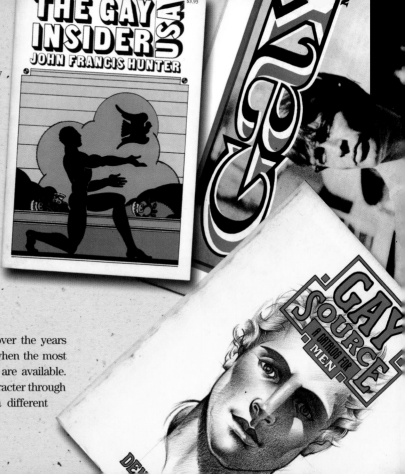

infiltration by those who had previously thought twice about entering our turf.

Seeing the Forest for the Bush (1999 to Present) Recent cultural, social, and political feelings show how many would love to dismantle gayborhoods completely, or at least alter what allows them to coalesce. For one, re-zoning can keep us away by forcing out businesses we are attracted to. Meanwhile, the warm embrace of assimilation has left many of us unaware that we—and our neighborhoods—might be on ground that has gotten much colder.

GIVE ME ONE MOMENT IN TIME

Our "fantastic journey" unfolds mainly over the years between the late '60s and the late '80s, when the most "show and tell" aspects of gayborhoods are available. *Greetings* whisks a "typical" gay male character through a dozen American cities representing a different

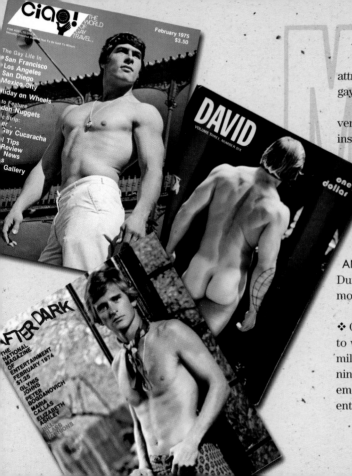

attraction as well as similar conditions leading to their gayborhood's prominence.

This dashing through towns and picking up souvenirs of short but pleasurable stays was further inspired by 1970s readers of *Bob Damron's Address Book* (and their infamous sly slogan: "See America; Find A Friend." A friend, indeed!). And because everything in gaydom before and after seemed to go different ways, 1978 was chosen the pivotal year for a "hot spots" site map using *Damron's* as a source.

AND ON THIS SIDE YOU WILL SEE …

During your "tour," be on the lookout for these common gayborhood characteristics.

❖ Gayborhoods always appear in very close proximity to work (and pleasurable pursuits). But universities, military installations, nice parks (for strolling, sunning, and surreptitiousness), and available forms of emergency egress (bus stations, tunnel and bridge entrances) are often within easy range.

❖ Gayborhoods often show up on "the wrong side of the tracks." Truly, their settings frequently have a railroad (or freeway) acting as a line of social demarcation! Such deliberate urban planning in the past cut off the very lifeblood of a place. Until we came along.

❖ Great distances are never in between successive gay enclaves. They generally form a "chain" as a matter of convenience, both economic and physical, and to keep our progressive strength intact.

❖ Easily defined and traversed borders provide a greater chance for long-term "gayness." Stretching things creates weak points. I offer the "straying gazelle" theory: place yourself away from the herd's core and you are apt to be taken down by stalking predators—like the straight ones hovering at the edges of *all* gayborhoods.

❖ In the beginning, gayborhoods grew slowly and organically. And none, even recently, has ever just appeared. They are all hermit-crab-like places where

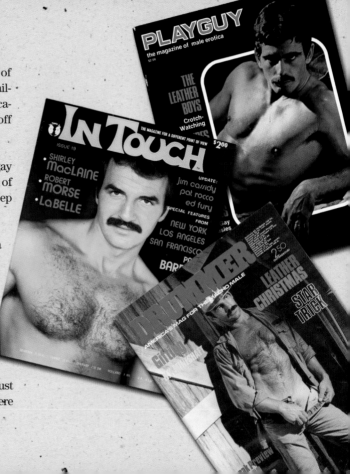

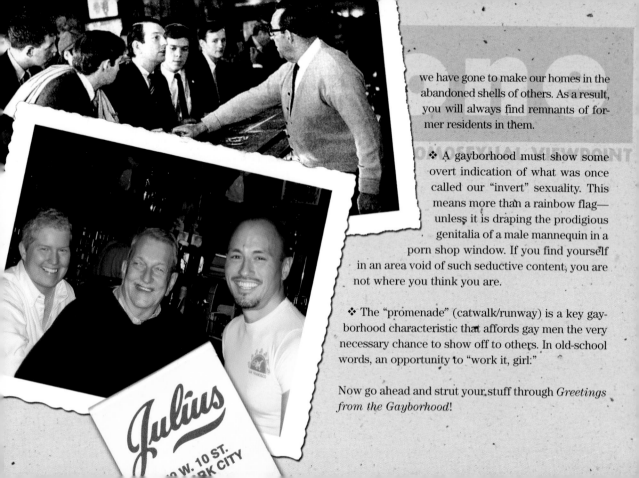

we have gone to make our homes in the abandoned shells of others. As a result, you will always find remnants of former residents in them.

❖ A gayborhood must show some overt indication of what was once called our "invert" sexuality. This means more than a rainbow flag—unless it is draping the prodigious genitalia of a male mannequin in a porn shop window. If you find yourself in an area void of such seductive content, you are not where you think you are.

❖ The "promenade" (catwalk/runway) is a key gayborhood characteristic that affords gay men the very necessary chance to show off to others. In old-school words, an opportunity to "work it, girl."

Now go ahead and strut your stuff through *Greetings from the Gayborhood*!

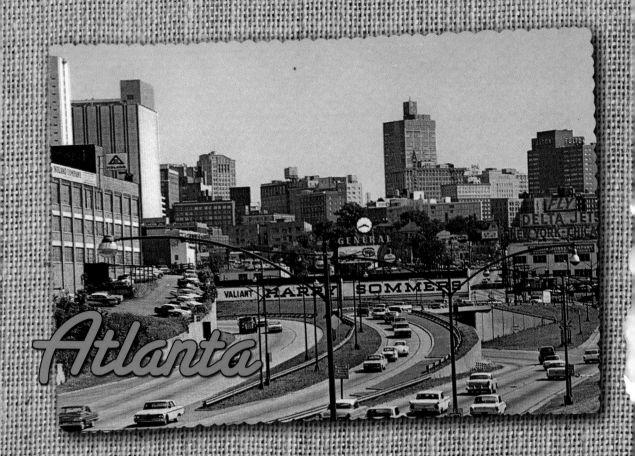

Atlanta

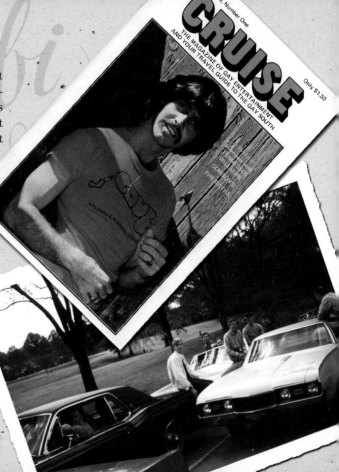

With so many to choose from, readers might wonder how *Greetings*'s dozen cities and gayborhoods were selected. Well, starting with Atlanta is a perfect way to explain, as it is so gaily charming that the rest should be as obvious. First, the city lies not only near the center of the state, but it is intellectually and culturally the heart of the entire southeastern United States. To emphasize the relevance of this positioning, just ask longtime residents what it means to venture outside the perimeter. The freeway does a lot more than *physically* encircle the city. Second, the combined highways of I-75 and I-85, cutting right through Atlanta's middle, helped jump-start its gayborhood by facilitating the conveyance of goods, services, and people through—*and away*—from its too-hardened core to suburbia and beyond. Consequently, like many other spots left behind in the era when people moved out of grimy, older inner cities, the area just north of the bisecting road fell into decline. Third, this

negative downturn exposed some positive upsides for us to take advantage of: Downtown, with its jobs, stores, and "fun" spots, is a "stone's throw" from this area now called Midtown (which was, when it seemed much farther away in days of old, called Uptown); Piedmont Park, large enough to lose one's self in all sorts of outdoor play (yet small enough to find your way out easily after doing so) takes up a substantial part of the territory; plenty of large, emptied (and then affordable) single and multiunit residences available for rent or purchase; colleges nearby bringing in the young and nubile to tarry about; loose zoning laws allowing for a variety of slightly unsavory businesses (from bars to bathhouses); and then, the ironic necessity of cars, which carried away so many. They were/are the best means to ferry us over the area's hills via winding, Indian-trail-based roads, to and from places a guy could never reach as easily on foot.

Notably, a fourth point *queerly* distinguishes Atlanta from the other eleven and more historically gay neighborhoods. While its plantation past is part

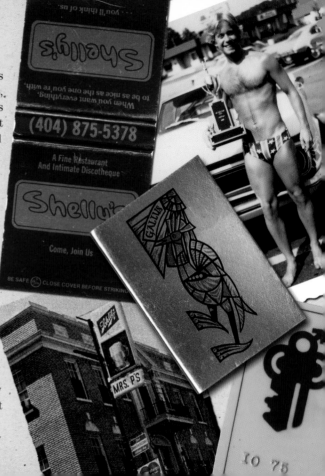

4

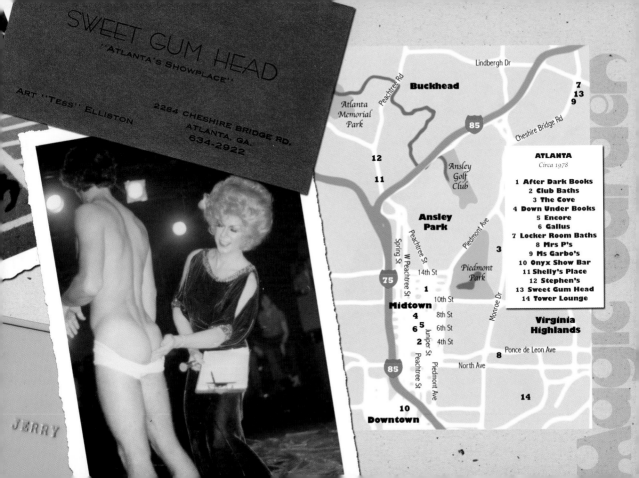

SWEET GUM HEAD

"ATLANTA'S SHOWPLACE"

ART "TESS" ELLISTON

2284 CHESHIRE BRIDGE RD.
ATLANTA, GA.
634-2922

JERRY

Lindbergh Dr

Buckhead

Peachtree Rd

Atlanta
Memorial
Park

85

Cheshire Bridge Rd

7
13
9

12

11

Ansley
Golf
Club

Ansley
Park

Piedmont Ave

3

Spring St

Peachtree St

W Peachtree St

14th St

1

10th St

Piedmont
Park

Monroe Dr

Midtown

4

8th St

6

5

6th St

Juniper St

2

4th St

Peachtree St

Piedmont Ave

85

North Ave

10

Downtown

Ponce de Leon Ave

8

Virginia
Highlands

14

ATLANTA
Circa 1978

1 **After Dark Books**
2 **Club Baths**
3 **The Cove**
4 **Down Under Books**
5 **Encore**
6 **Gallus**
7 **Locker Room Baths**
8 **Mrs P's**
9 **Ms Garbo's**
10 **Onyx Show Bar**
11 **Shelly's Place**
12 **Stephen's**
13 **Sweet Gum Head**
14 **Tower Lounge**

of the allure, and our presence in that moss-draped history is unequivocal, the city prides itself on being quite modern-minded. Comparing the early 1960s postcard view (on page 2) with current ones is indisputable evidence of physical success. But achieving the same philosophically took more than building upward. For that, the city's forward thinkers needed to deliberately put asunder any perceptions of Atlanta as a typical Deep South "backwoods" town. And succeed they did. Among other things, the "ATL" is widely regarded as thoughtfully diverse a place as any. And "gay" Midtown grew in direct relation to this thoughtfulness.

Even so, Midtown is a relative latecomer to the festivities—and notably showing signs of an early departure. (Oh, we gay boys and our party rules!) One need only take a look around the area—*Where did Backstreet go? The Armory?*—to see indications of us not being where we were just a few scant years ago.

GOVERNMENT ID WITH PHOTO REQUIRED

1987

THE Pharr LIBRARY

I.B.

weeken

ATLANTA EAGLE
306 E. Ponce de Leon Ave.
Atlanta, Georg

404 87-5

0000727

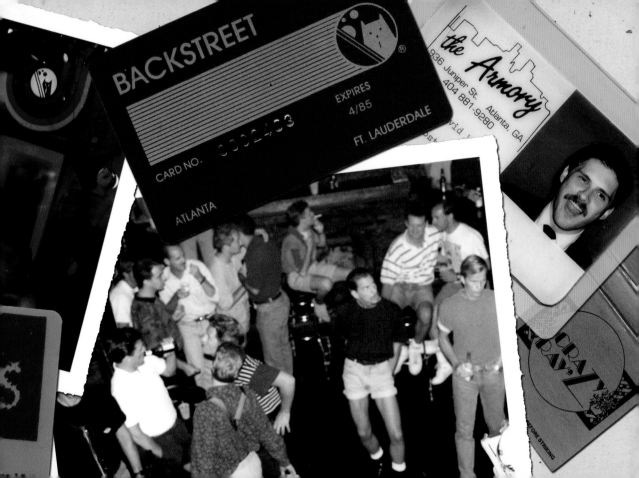

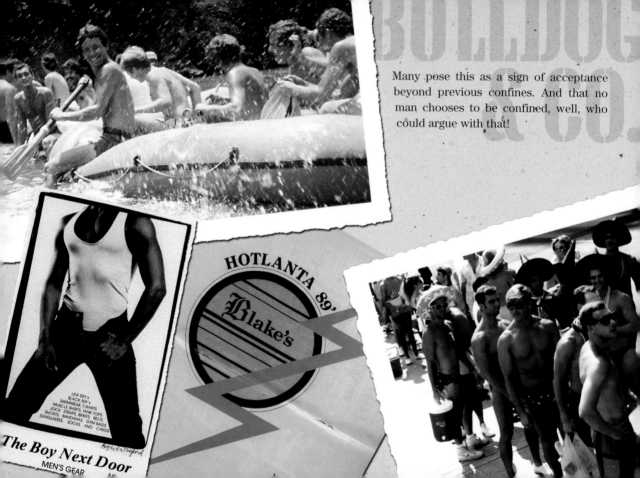

Many pose this as a sign of acceptance beyond previous confines. And that no man chooses to be confined, well, who could argue with that!

HOTLANTA 89'

Blake's

The Boy Next Door
MEN'S GEAR

LEVI 501's
BLACK 501's
SWIMWEAR, T-SHIRTS
MUSCLE SHIRTS, TANK TOPS
JOCK STRAPS, BRIEFS, BELTS
SHORTS, BANDANAS, GYM BAGS
SUNGLASSES, SOCKS AND CARDS

Boston

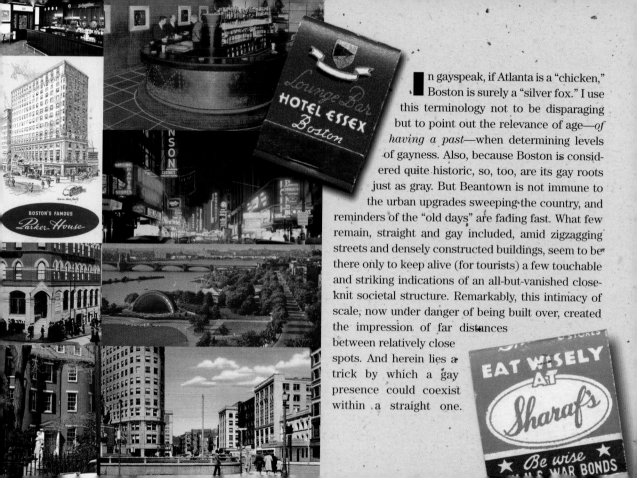

In gayspeak, if Atlanta is a "chicken," Boston is surely a "silver fox." I use this terminology not to be disparaging but to point out the relevance of age—*of having a past*—when determining levels of gayness. Also, because Boston is considered quite historic, so, too, are its gay roots just as gray. But Beantown is not immune to the urban upgrades sweeping the country, and reminders of the "old days" are fading fast. What few remain, straight and gay included, amid zigzagging streets and densely constructed buildings, seem to be there only to keep alive (for tourists) a few touchable and striking indications of an all-but-vanished close-knit societal structure. Remarkably, this intimacy of scale, now under danger of being built over, created the impression of far distances between relatively close spots. And herein lies a trick by which a gay presence could coexist within a straight one.

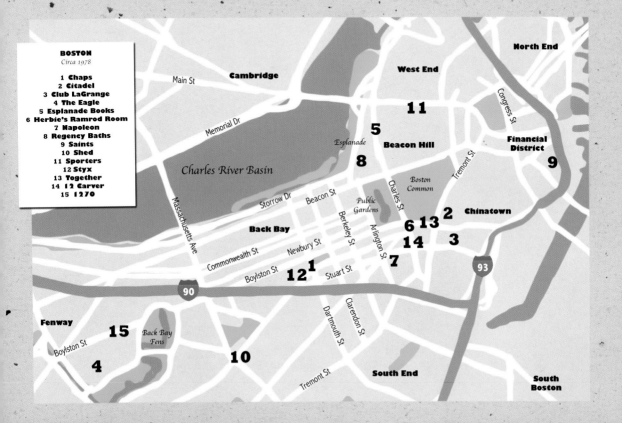

BOSTON
Circa 1978

1 Chaps
2 Citadel
3 Club LaGrange
4 The Eagle
5 Esplanade Books
6 Herbie's Ramrod Room
7 Napoleon
8 Regency Baths
9 Saints
10 Shed
11 Sporters
12 Styx
13 Together
14 12 Carver
15 1270

Main St

Cambridge

West End

North End

Memorial Dr

Esplanade

11

5

Beacon Hill

Congress St

Financial District

8

Charles River Basin

Storrow Dr

Beacon St

Boston Common

Tremont St

9

Massachusetts Ave

Back Bay

Newbury St

Public Gardens

Charles St

Berkeley St

Arlington St

6 13 2

Chinatown

14

Commonwealth St

Boylston St

12 1

Stuart St

3

7

90

93

Fenway

15

Back Bay Fens

Clarendon St

Dartmouth St

10

Boylston St

4

Tremont St

South End

South Boston

Before we became better known, it was widely accepted that we did not exist at all. Because people could not distinguish us from others made "hiding in plain sight" quite possible. Furthermore, relative ignorance on the part of the general public allowed for the most flagrant activity to flower right under their noses. (Ahh, the good old days!)

But even as our audacity was able to blossom, Boston's inner-core was bursting out of its bud. City planners dealt with the overcrowded conditions by filling in land and creating the South End (notably across the railroad tracks and the Mass Turnpike). It became an instant residential success. But to the west, they did the same thing and made the Back Bay, where high-toned folks flocked. This left a not-so-lofty crowd to move to the South End—and a crowd that was remarkably mixed. It was this cross-cultural distinction, along with the area's closeness to commerce and such, that led numbers of single males here, too.

It would be most prudent to interject here that many consider Beacon Hill Boston's first residence of note for the "bachelor" set. And understandably so. It lies closer to the center of "old" Boston (and was where its highest strata of society once lived); it is right next to a highway; and the population was notably reduced postwar. *Now, voyagers*, what dandy would not want to reside in a formerly fancy townhome not unlike one used on a tony Bette Davis movie set?

But tightness (of place and spirit) was also the Hill's undoing. Gay Boston's younger generations needed, like the city itself, growing room. So, to the South End we did wend. Yet in a manner most unusual. With the exception of certain kinds of clothing stores, restaurants, and bookstores—and the occasional "after-hours" joint—we left most evidence of our lifestyle (bars, baths, clubs, etc.) back on the other side of the divide. As a result, the South End became a uniquely gay "bedroom" community, devoid of the fuss allowed only through loose zoning laws and office areas vacated for the night.

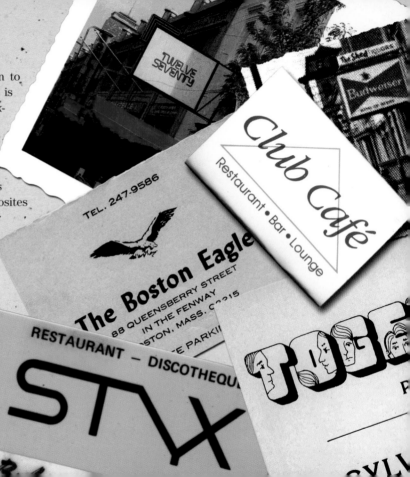

Finally, Boston is well known to have an upper-crusty aura. But it is also, to the contrary, quite the working-class town. Thus, its gay milieu mixes the collegiate and to-the-manor-born martini sippers with beer-swilling "good old boy" types. Another contradiction has to do with its inescapable "opposites attract" closeness to a gayer (more prurient and slightly less Puritanical) pair of neighbors: New York City and Provincetown, Massachusetts. Being that it's just a commuter ride away, the Big Apple's attractions naturally pose a constant temptation of impropriety to proper Bostonians. But P-town's *gay*-lure is a foggier proposition. To put it

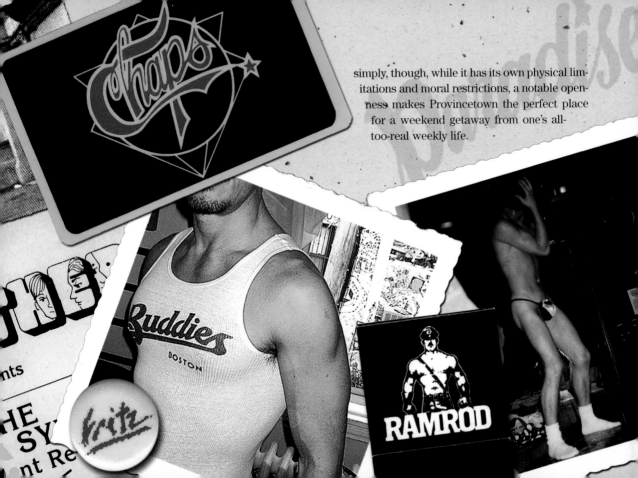

simply, though, while it has its own physical limitations and moral restrictions, a notable openness makes Provincetown the perfect place for a weekend getaway from one's all-too-real weekly life.

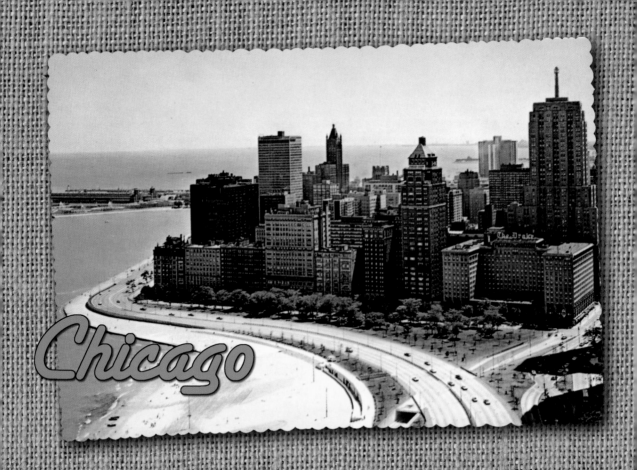

Chicago

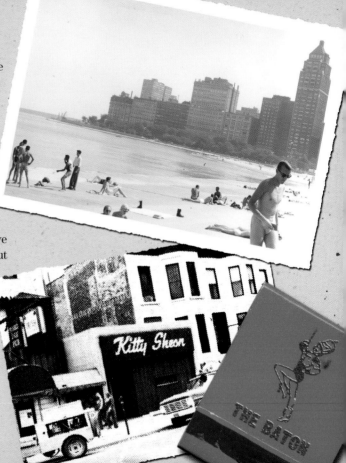

One look at a map and it should be plain to see what makes Chicago a draw, especially to its America's heartland neighbors. As a former heartland "boy" myself, I understood that it was compellingly gay, too. But in a different way than, say, faraway San Francisco or New York. Chicago offered big-city sophistication close by, but tempered it with Midwestern values. Consequently, its *oeuvre* has never been particularly "so gay."

This ethos may explain why Chicago was the first city to open a gay leather bar, the Gold Coast. The need at the time (c. 1959) may only have been about giving gruff patrons what they wanted. But in hindsight it says more about how one city's defining gay community dealt with general issues of masculinity, femininity, and sexuality. An inescapable aspect of Midwestern mentality is the distinction between how real men should and should not behave. Therein was the same awareness among gay Chicagoans. As a result, many bars grew from this strict and manly mindset. But it was possible for male citizenry to flaunt

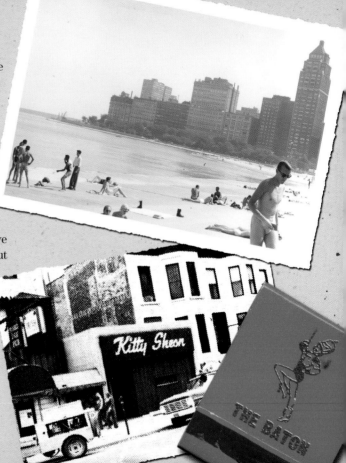

their very flamboyant sides, too. And Illinois was the first state to decriminalize sodomy (in the early '60s). All told, this gave the region a diversity impossible in places not as broadly spaced or minded.

Due to its wide-openness, the "movement" of Chicago's gay community is also the most traceable of the twelve cities in *Greetings*. To begin, while the area of Lakeview may be the best known (better known as Boystown), it is not Chicago's first gayborhood. That distinction goes to both the residential Gold Coast area (just north and west of Oak Street, and in parts just south once referred to as "Towertown," because they were close to the Water Tower) and the commercial Near North (due west of Michigan Avenue, "north" of the Chicago River, where the Gold Coast leather bar first opened). We also gathered, rather covertly,

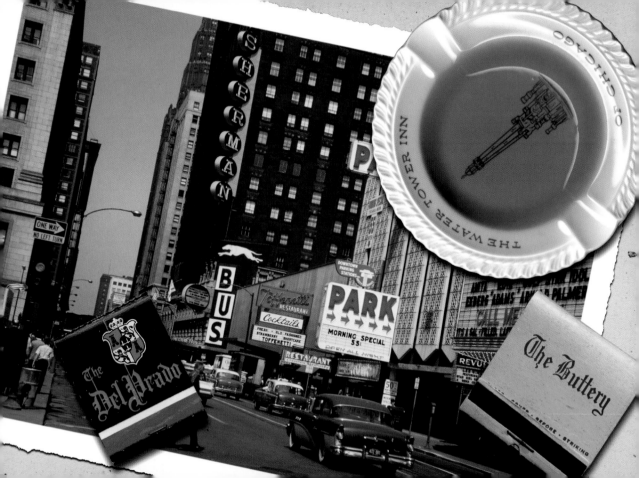

on the blocks in between: cruising through Washington "Bughouse" Square; crossing at the intersection of Dearborn and Division (once disparagingly referred to by law enforcement as the corner of "Queerborn and Perversion"); cajoling in cocktail lounges, like the swank Dome Bar at the Sherman Hotel; and crashing for an hour, or the night, at the local YMCA. Notably, these now spiffy areas were left to decay after WWII. Next, expanding internal and external awareness took gay Chicago north to "Old Town" (and that naughty lagoon in Lincoln Park).

20

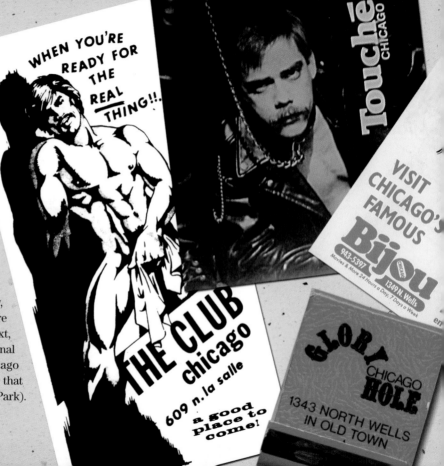

WHEN YOU'RE READY FOR THE REAL THING!!

THE CLUB chicago
609 n. la salle
a good place to come!

Touché CHICAGO

GLORY CHICAGO HOLE
1343 NORTH WELLS
IN OLD TOWN

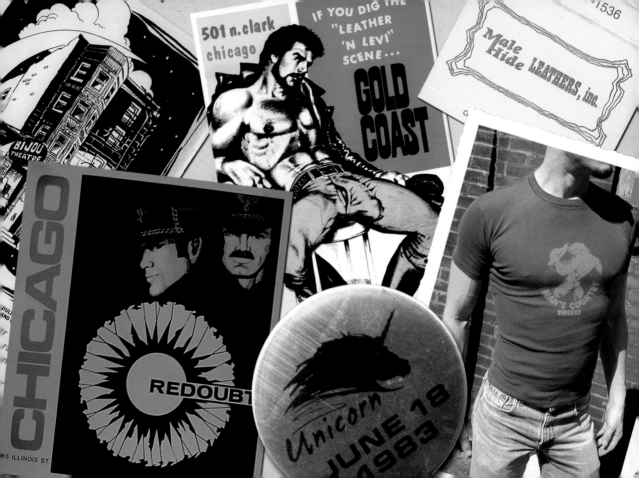

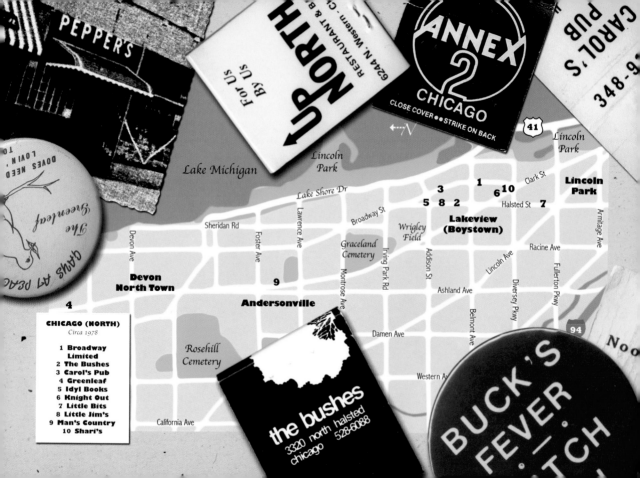

PEPPER'S

UPNORTH
RESTAURANT & B...
6244 N. Western...
For Us
By Us

ANNEX
2
CHICAGO
CLOSE COVER ••STRIKE ON BACK

CAROL'S
PUB
348-9...

LOVIN...
DOVES NEED...

The Greenleaf

GAYS AT PEA...

41

Lincoln
Park

Lake Michigan

Lincoln
Park

Lake Shore Dr

1

3 2

6 10 Clark St

Lincoln
Park

5 8 2 Halsted St 7

Lakeview
(Boystown)

Sheridan Rd

Broadway St

Wrigley
Field

Lincoln Ave

Racine Ave

Armitage Ave

Foster Ave

Lawrence Ave

Graceland
Cemetery

Addison St

Diversey Pkwy

Fullerton Pkwy

Devon Ave

Devon
North Town

9

Irving Park Rd

Montrose Ave

Ashland Ave

Belmont Ave

94

Andersonville

Noo...

Rosehill
Cemetery

Damen Ave

BUCK'S
FEVER
...TCH

CHICAGO (NORTH)
Circa 1978

1 Broadway
 Limited
2 The Bushes
3 Carol's Pub
4 Greenleaf
5 Idyl Books
6 Knight Out
7 Little Bits
8 Little Jim's
9 Man's Country
10 Shari's

California Ave

Western Av...

the bushes
3320 north halsted
chicago 528-6088

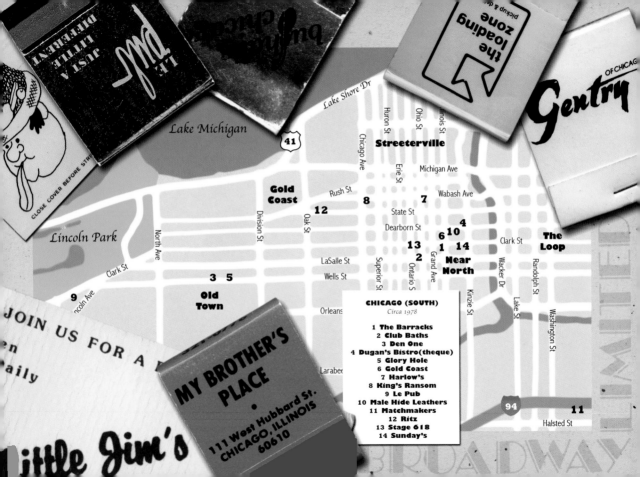

JUST A
LITTLE
DIFFERENT

Le Pub

CLOSE COVER BEFORE STRIKING

buffalo chips

the loading zone
pickup & delivery

Gentry
OF CHICAGO

Lake Shore Dr

Lake Michigan

41

Huron St
Ohio St
Illinois St

Chicago Ave

Streeterville

Erie St
Michigan Ave

Gold
Coast

Rush St
Wabash Ave

8 7

12

State St

Dearborn St
4
10
6
13 1 14

Division St

Oak St

Lincoln Park

North Ave

LaSalle St

Wells St

Superior St

Ontario St

Grand Ave

Clark St

The
Loop

Clark St

Near
North

Wacker Dr

Randolph St

Washington St

3 5

9

Lincoln Ave

Orleans

Old
Town

Larabee

Kinzie St

Lake St

JOIN US FOR A

en

aily

MY BROTHER'S
PLACE
•
111 West Hubbard St.
CHICAGO, ILLINOIS
60610

CHICAGO (SOUTH)
Circa 1978

1 **The Barracks**
2 **Club Baths**
3 **Den One**
4 **Dugan's Bistro(theque)**
5 **Glory Hole**
6 **Gold Coast**
7 **Harlow's**
8 **King's Ransom**
9 **Le Pub**
10 **Male Hide Leathers**
11 **Matchmakers**
12 **Ritz**
13 **Stage 618**
14 **Sunday's**

94

11

Halsted St

BROADWAY

Little Jim's

LIMITED

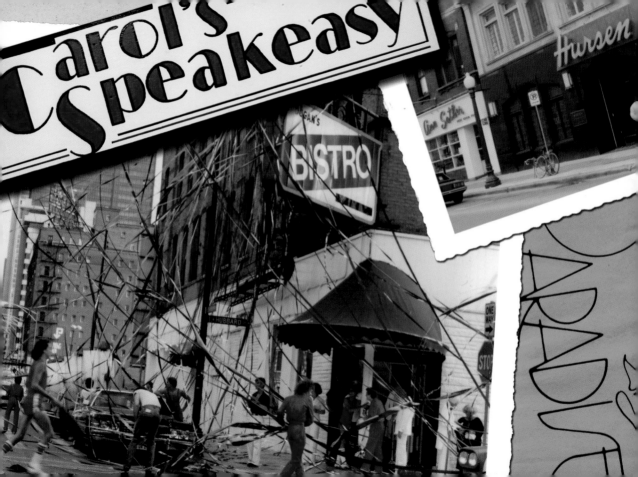

Thereafter, we ended up in Lakeview, and dubbed it "New Town."

Though we made inroads throughout the area in the '70s, the neighborhood was still very transitional (non-gay-to-gay and non-white-to-white) throughout much of the decade. Its eventual nickname, "Boystown," is a testament to its successful gay emergence in the early '80s. And the use of "boys" in Boystown had additional profound meaning. The term engenders the "youthfulness" and "purity" expected of the place and its denizens. Surely a subconscious motivation for this name was to disconnect from "maturer" gay generations and their suddenly shameful ways. If you are not convinced, consider if Lakeview's gayness had risen just a few years earlier. Might it more than likely have been lustfully designated as "Daddytown" or "Manstown" instead?

On a less prophetic note, if you have a way to view Chicago's transportation system, mainly its famed El (short for elevated) railway, you slim-bodied sleuths should notice that the city's gay presence was never far from the tracks. We were also wedged in between them and the elegant shores of Lake Michigan. Put together, these are indications (at least in the beginning) of our needing closeness for comfort. But Chicago seems already to have taken the next logical step in its gaily progressive evolution. Newer "friendly" neighborhoods, like Andersonville, have reached farther along the tracks and farther from the lake.

Fort Lauderdale

Thanks to the movie and song, Fort Lauderdale is known, adoringly, as "where the boys are." But something occurred here—of a truly "boyish" nature—that really earned it the phrase. During the '20s and '30s, as swimming and diving grew increasingly popular as sports, many northern universities looked to South Florida for training and competition spots. Bear in mind, too, that in those days college athletics were largely masculine endeavors. Fort Lauderdale became the favorite "sunny" destination due partly to its location between Palm Beach and Miami. In the process, its reputation as the gathering spot for lithe Lotharios, and for those who followed them, was sealed.

This should explain Lauderdale's inclusion here, but may not adequately justify why it was chosen over (gayer) Miami and Miami Beach. Well, *Greetings* takes a distinctly American look at the subject through each city's dominantly gay neighborhood. But because Miami is quite international in flavor, and since Miami Beach's popularity made it a largely mainstream hangout, devoid of any overwhelmingly

ODDS & ENDS

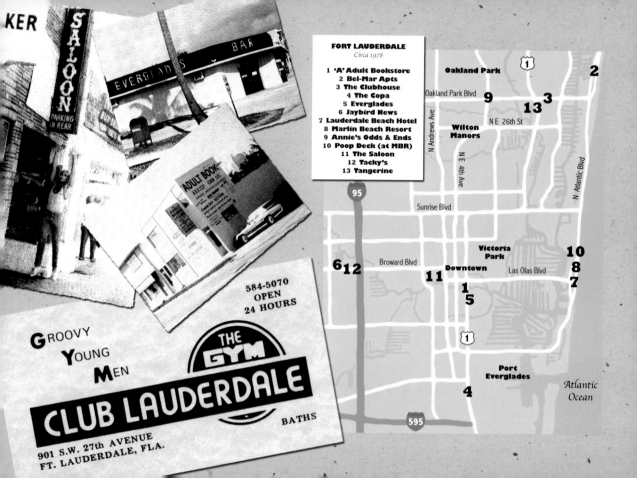

FORT LAUDERDALE
Circa 1978

1 'A' Adult Bookstore
2 Bel-Mar Apts
3 The Clubhouse
4 The Copa
5 Everglades
6 Jaybird News
7 Lauderdale Beach Hotel
8 Marlin Beach Resort
9 Annie's Odds & Ends
10 Poop Deck (at MBR)
11 The Saloon
12 Tacky's
13 Tangerine

GROOVY YOUNG MEN

THE GYM

CLUB LAUDERDALE

BATHS

584-5070
OPEN
24 HOURS

901 S.W. 27th AVENUE
FT. LAUDERDALE, FLA.

Oakland Park

Oakland Park Blvd

Wilton Manors

N Andrews Ave

N.E. 26th St

N.E. 4th Ave

N Atlantic Blvd

Sunrise Blvd

Victoria Park

Broward Blvd

Downtown

Las Olas Blvd

Port Everglades

Atlantic Ocean

queer area (even in South Beach), they didn't quite fit the book's criteria. On the other hand, Fort Lauderdale did. Its "homey" vibe has always drawn a decidedly domestic, and markedly mature, gay male crowd. In turn, these "daddies" attract the many "boys" attracted to their type. Further, among the dozen cities in *Greetings*, Lauderdale offers the unique duality of being both a live-in city and fave vacation spot, which gives rambunctious residents or visitors the benefits of meeting a new set of friends—*with benefits*—on a consistent basis. (Boys will be boys!)

Lauderdale's general affordability also drew us in, and is a reminder that the notion that we (singly or as DINK—dual income, no kids—couples) have money to burn is as false as a drag queen's lashes. Nevertheless, the closest the city had to a typical gayborhood was Victoria "Vicky" Park during the '70s. But seasonal population fluctuations never allowed it to gaily make itself over the way other places had. Things changed once Wilton Manors, an island city with water boundaries (like the roads and

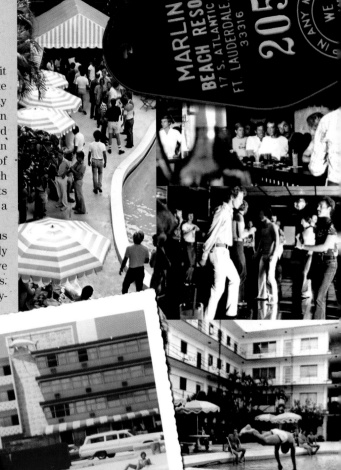

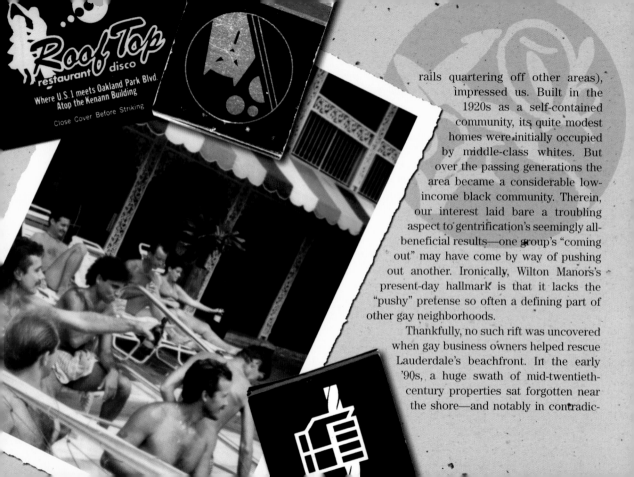

Roof Top
restaurant disco

Where U.S.1 meets Oakland Park Blvd.
Atop the Kenann Building

Close Cover Before Striking

rails quartering off other areas), impressed us. Built in the 1920s as a self-contained community, its quite modest homes were initially occupied by middle-class whites. But over the passing generations the area became a considerable low-income black community. Therein, our interest laid bare a troubling aspect to gentrification's seemingly all-beneficial results—one group's "coming out" may have come by way of pushing out another. Ironically, Wilton Manors's present-day hallmark is that it lacks the "pushy" pretense so often a defining part of other gay neighborhoods.

Thankfully, no such rift was uncovered when gay business owners helped rescue Lauderdale's beachfront. In the early '90s, a huge swath of mid-twentieth-century properties sat forgotten near the shore—and notably in contradic-

tion to our late '80s awareness of Miami Beach's Deco district. But soon to these encampments came entrepreneurs style-appreciative of their oh-so-campy—but chicly so—value. Seemingly overnight they were restored to their former glory. But with an intriguing update. Where sun had once shone unhindered from sidewalk to windowsill, dense greenery now protected the very private goings-on within from the view of a likely perturbed public. (Again, boys will be boys!)

This behind-closed-doors policy was a signature of one Lauderdale spot of great gay note: the Xanadu-like Marlin Beach Resort. This midsize, late-'50s-built, oceanfront resort (coincidentally used in the closing scene of *Where the Boys Are*) became iconic when new owners, in the late '60s, deliberately made it into a total gay-stay experience. With just about eighty rooms, its size was dwarfed by most hotels, then or now. But think of the "living large" experience this gave vacationers out for a "gay" time with its disco, the Poop Deck,

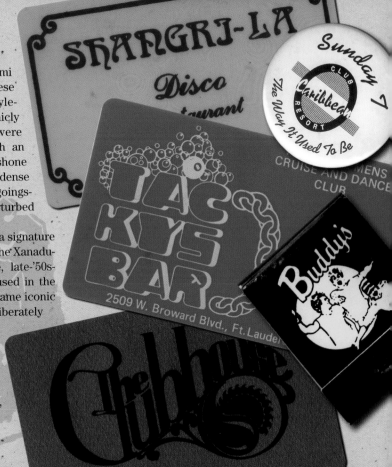

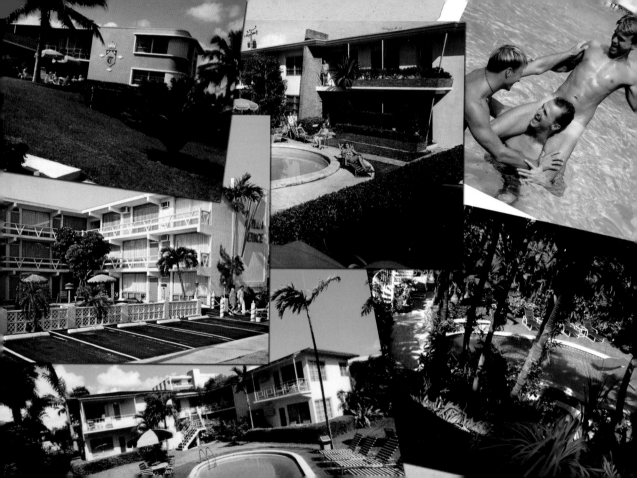

restaurant, gift shop, private beach access, and sunset tea dance *extraordinaire*! However, like all sand castles, this shoreline sentinel's watch could not last forever; although at a near-quarter-century its endurance was remarkably long-lasting—especially in "gay years!" And in true one-of-a-kind, exclusive fashion, no others have successfully risen in its place. Here or elsewhere. Then or now.

TROPICS
RESTAURANT
PIANO BAR
CABARET

2000 Wilton Drive
(N.E. 4th AVE.)
Wilton Manors, Fl. 33305

Georgie's

ALIBI
FORT LAUDERDALE
VIDEO BAR
CAFE AND
SPORTS BAR

Bill's
FILLING STATION

FORT LAUDERDALE
RAMROD
A LEVI/LEATHER/UNIFORM BAR

THE EAGLE
1951 Powerline Road
Ft. Lauderdale · Florida
(305) 462

CHARDEES
SUPPER CLUB

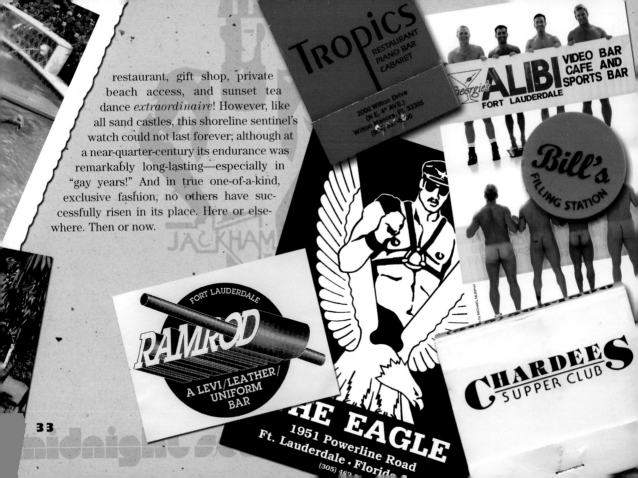

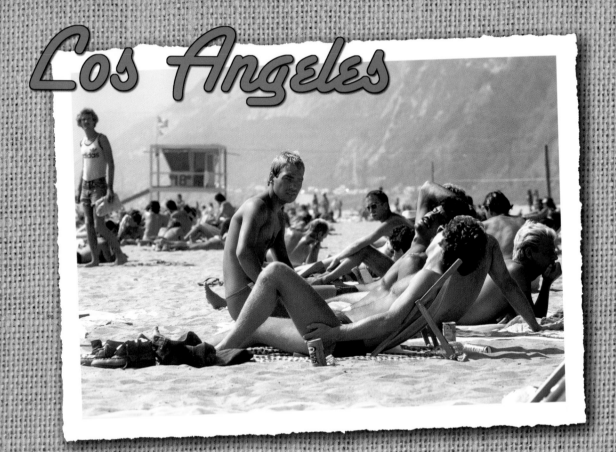

Los Angeles

One cannot write honestly about any part of gay Los Angeles without mentioning cars. Yes, cars! Frankly, we could never have gotten around—or together—without them. There is an irony here, too. The cars coursing through Los Angeles's "six suburbs in search of a city" are evidence of the general (straight) population's move away from urban centers. We used them for essentially the opposite: to navigate and "cruise" the city's still vast core. And no other city's gayness and growth has this same level of car connection.

Then there's showbiz! Truly, could a business be any more attractive to "creative" types? Or one drawing as many attractive men to stand in front of the cameras, even if it meant being first cast on a couch? As a result, one perceives Los Angeles as filled with good-looking guys, those who might care too much about looks, those who will use their looks to get whatever they can, those who are paid handsomely to determine who has and hasn't got them, and those who feel they are more beautiful just being in the company of any of them.

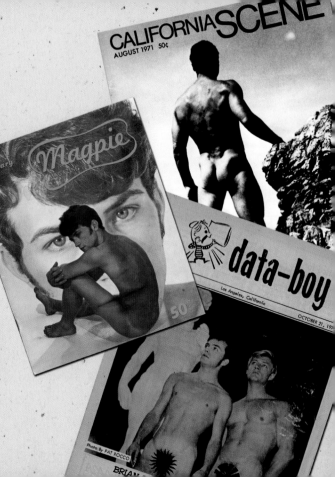

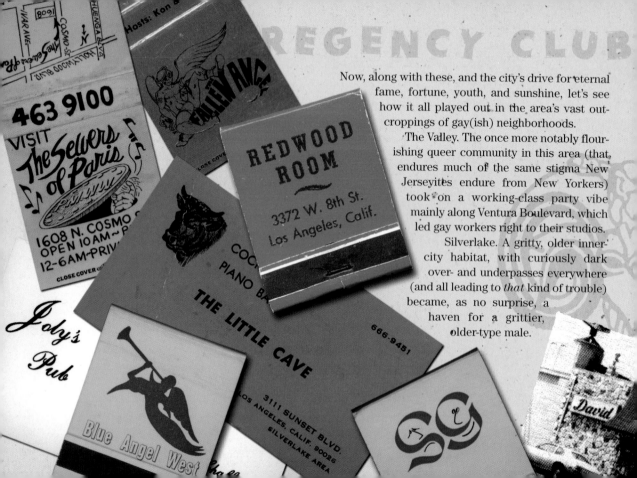

Now, along with these, and the city's drive for eternal fame, fortune, youth, and sunshine, let's see how it all played out in the area's vast out-croppings of gay(ish) neighborhoods.

The Valley. The once more notably flourishing queer community in this area (that endures much of the same stigma New Jerseyites endure from New Yorkers) took on a working-class party vibe mainly along Ventura Boulevard, which led gay workers right to their studios.

Silverlake. A gritty, older inner-city habitat, with curiously dark over- and underpasses everywhere (and all leading to *that* kind of trouble) became, as no surprise, a haven for a grittier, older-type male.

463 9100

VISIT *The Sewers of Paris*

1608 N. COSMO
OPEN 10AM~P
12-6AM-PRIV
CLOSE COVER OF

FALLEN ANGE
CLOSE COVER

REDWOOD ROOM

3372 W. 8th St.
Los Angeles, Calif.

COC
PIANO B

Joly's Pub

THE LITTLE CAVE

3111 SUNSET BLVD.
LOS ANGELES, CALIF. 90026
SILVERLAKE AREA

666-9481

Blue Angel West

David

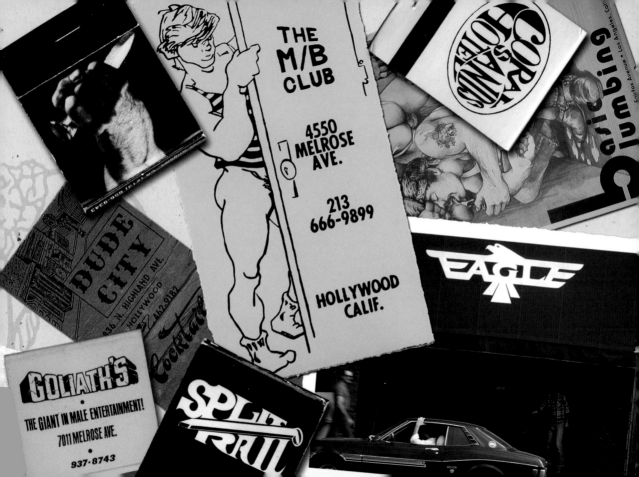

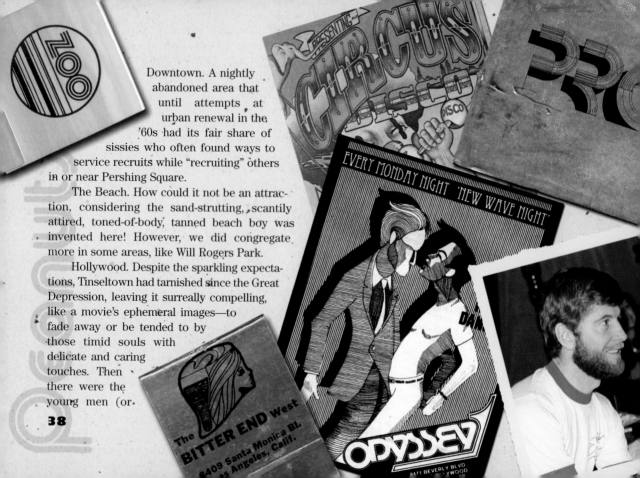

Downtown. A nightly abandoned area that until attempts at urban renewal in the '60s had its fair share of sissies who often found ways to service recruits while "recruiting" others in or near Pershing Square.

The Beach. How could it not be an attraction, considering the sand-strutting, scantily attired, toned-of-body, tanned beach boy was invented here! However, we did congregate more in some areas, like Will Rogers Park.

Hollywood. Despite the sparkling expectations, Tinseltown had tarnished since the Great Depression, leaving it surreally compelling, like a movie's ephemeral images—to fade away or be tended to by those timid souls with delicate and caring touches. Then there were the young men (or

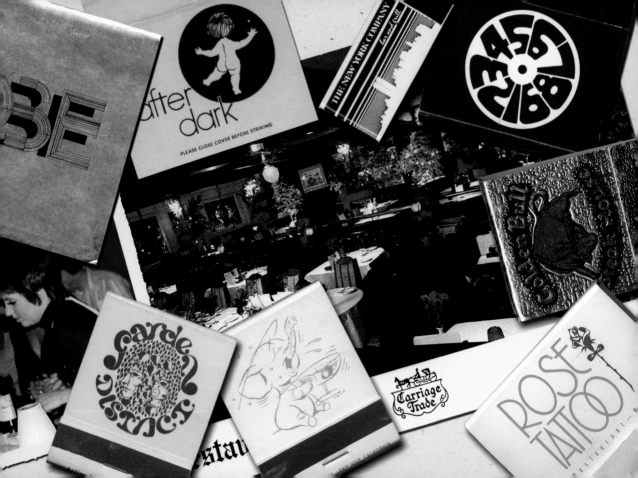

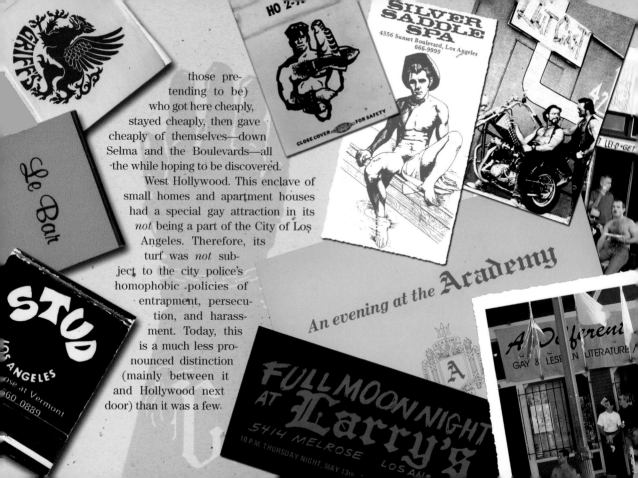

those pre-
tending to be)
who got here cheaply,
stayed cheaply, then gave
cheaply of themselves—down
Selma and the Boulevards—all
the while hoping to be discovered.

West Hollywood. This enclave of
small homes and apartment houses
had a special gay attraction in its
not being a part of the City of Los
Angeles. Therefore, its
turf was *not* sub-
ject to the city police's
homophobic policies of
entrapment, persecu-
tion, and harass-
ment. Today, this
is a much less pro-
nounced distinction
(mainly between it
and Hollywood next
door) than it was a few.

GRIFF'S

Le Bar

STUD
LOS ANGELES
Melrose at Vermont
660-0889

HO 2-

CLOSE COVER FOR SAFETY

SILVER
SADDLE
SPA
4356 Sunset Boulevard, Los Angeles
666-9999

An evening at the Academy

A Different
GAY & LESBIAN LITERATURE

FULL MOON NIGHT
AT Larry's
5414 MELROSE LOS AN
10 P.M. THURSDAY NIGHT, MAY 13th

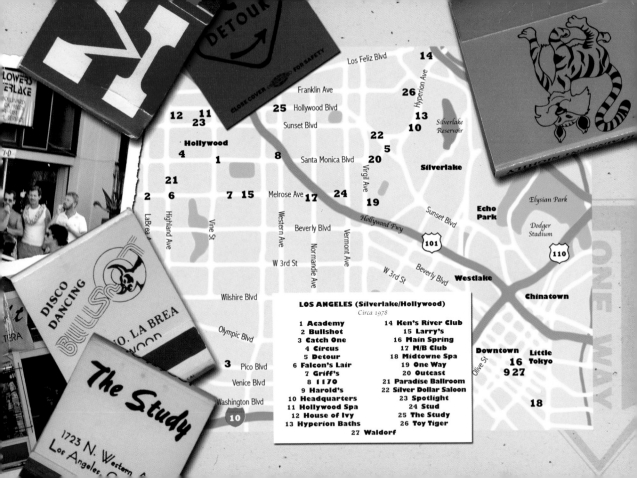

DETOUR

CLOSE COVER FOR SAFETY

Los Feliz Blvd

14

Franklin Ave

26 Hyperion Ave

25 Hollywood Blvd

Sunset Blvd

13

Hollywood

12 11
23

10

Silverlake Reservoir

4

1

8

Santa Monica Blvd

22

5

20

Silverlake

21

6

7 15

Melrose Ave 17

24

19

Virgil Ave

Elysian Park

2

Highland Ave

Vine St

Western Ave

Beverly Blvd

Normandie Ave

Vermont Ave

Hollywood Fwy

Sunset Blvd

Echo Park

Dodger Stadium

101

110

W 3rd St

W 3rd St

Beverly Blvd

Westlake

Chinatown

LOWERS
ERLAKE

DISCO DANCING BULLS

NO. LA BREA
WOOD

The Study

1723 N. Western
Los Angeles

Wilshire Blvd

Olympic Blvd

3

Pico Blvd

Venice Blvd

Washington Blvd

10

Downtown

Olive St

16

9 27

Little Tokyo

18

ONE WAY

LOS ANGELES (Silverlake/Hollywood)

Circa 1978

1 **Academy**
2 **Bullshot**
3 **Catch One**
4 **Circus**
5 **Detour**
6 **Falcon's Lair**
7 **Griff's**
8 **1170**
9 **Harold's**
10 **Headquarters**
11 **Hollywood Spa**
12 **House of Ivy**
13 **Hyperion Baths**

14 **Ken's River Club**
15 **Larry's**
16 **Main Spring**
17 **M/B Club**
18 **Midtowne Spa**
19 **One Way**
20 **Outcast**
21 **Paradise Ballroom**
22 **Silver Dollar Saloon**
23 **Spotlight**
24 **Stud**
25 **The Study**
26 **Toy Tiger**

27 **Waldorf**

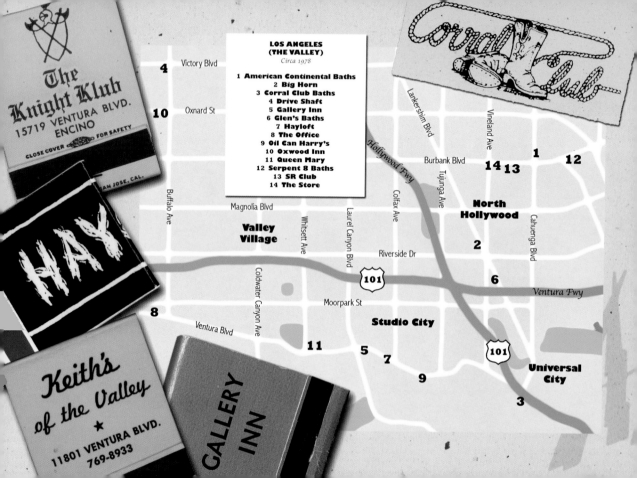

The Knight Klub
15719 VENTURA BLVD.
ENCINO
CLOSE COVER FOR SAFETY

SAN JOSE, CAL.

HAY

Keith's
of the Valley
★
11801 VENTURA BLVD.
769-8933

GALLERY INN

Corral Club

**LOS ANGELES
(THE VALLEY)**
Circa 1978

1 American Continental Baths
2 Big Horn
3 Corral Club Baths
4 Drive Shaft
5 Gallery Inn
6 Glen's Baths
7 Hayloft
8 The Office
9 Oil Can Harry's
10 Oxwood Inn
11 Queen Mary
12 Serpent 8 Baths
13 SR Club
14 The Store

Victory Blvd
Oxnard St
Buffalo Ave
Magnolia Blvd
Whitsett Ave
Laurel Canyon Blvd
Colfax Ave
Lankershim Blvd
Vineland Ave
Burbank Blvd
Tujunga Ave
Cahuenga Blvd
Hollywood Fwy

North Hollywood

Valley Village

Coldwater Canyon Ave
Riverside Dr

Ventura Blvd
Moorpark St

Studio City

Ventura Fwy

Universal City

4
10
8
11
5
7
9
3
1
12
14 13
2
6
101
101

decades ago, when being homosexual was against the law (and in some places remains so). But its onetime prevalence goes well beyond California's borders to show how public policy made every difference in determining where we ended up.

WeHo, as it is now commonly called, also became the place for gay men to be "seen" (a legacy of the "look-at-me" personalities of the wannabe stars who flocked here). Further still, it took the spotlight in a remarkable way by offering the most iconic version of the "poster boy"—a marvelous example of the male sex, who, with his gleamingly hairless, buff, blond, and blue-eyed countenance, signaled a new, less sexually inclined gay way of life. And one that has only recently started reverting to old sexy (and dangerous) habits.

Rather perplexingly, as

43

gaily prominent as WeHo remains, it is rumored to be patronized much more by queer outsiders than many of the gay "in crowd." It "appears" as though this savvy group still worries that making an appearance here—in a town where the public's perception is key to their success—will label them harmfully. Therefore, it is not to the gayborhood that these types typically go, as it is with their numbers in other cities as well. Instead, they frequent "mixed" social opportunities, where being perceived at least as sexually ambivalent is the *out*come they expect from showing their faces.

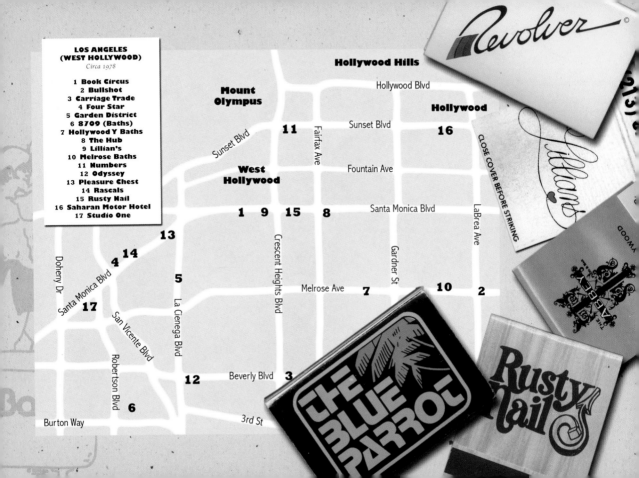

**LOS ANGELES
(WEST HOLLYWOOD)**
Circa 1978

1 **Book Circus**
2 **Bullshot**
3 **Carriage Trade**
4 **Four Star**
5 **Garden District**
6 **8709 (Baths)**
7 **Hollywood Y Baths**
8 **The Hub**
9 **Lillian's**
10 **Melrose Baths**
11 **Numbers**
12 **Odyssey**
13 **Pleasure Chest**
14 **Rascals**
15 **Rusty Nail**
16 **Saharan Motor Hotel**
17 **Studio One**

Hollywood Hills

Hollywood Blvd

**Mount
Olympus**

Sunset Blvd

Hollywood

Sunset Blvd

11 16

Fairfax Ave

**West
Hollywood**

Fountain Ave

Sunset Blvd

1 9 15 8 Santa Monica Blvd

LaBrea Ave

Crescent Heights Blvd

Gardner St

13

4 14

Doheny Dr

5

Santa Monica Blvd

La Cienega Blvd

Melrose Ave 7 10 2

17

San Vicente Blvd

Robertson Blvd

12 Beverly Blvd 3

6

Burton Way 3rd St

Revolver

(213) 6

Lillians

CLOSE COVER BEFORE STRIKING

THE ABBEY

-WOOD

THE
BLUE
PARROT

*Rusty
Nail*

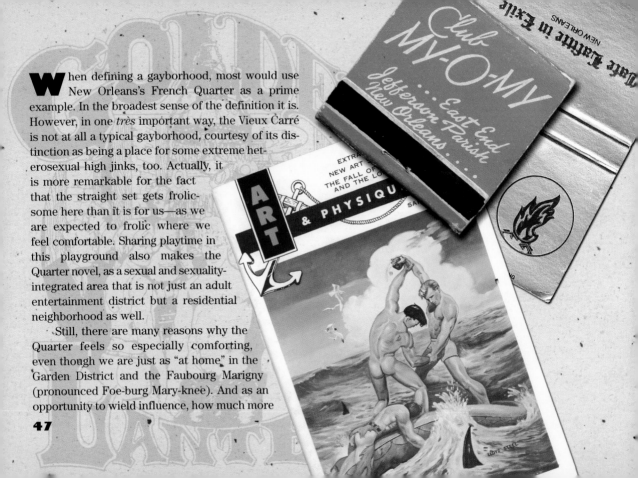

When defining a gayborhood, most would use New Orleans's French Quarter as a prime example. In the broadest sense of the definition it is. However, in one *très* important way, the Vieux Carré is not at all a typical gayborhood, courtesy of its distinction as being a place for some extreme heterosexual high jinks, too. Actually, it is more remarkable for the fact that the straight set gets frolicsome here than it is for us—as we are expected to frolic where we feel comfortable. Sharing playtime in this playground also makes the Quarter novel, as a sexual and sexuality-integrated area that is not just an adult entertainment district but a residential neighborhood as well.

Still, there are many reasons why the Quarter feels so especially comforting, even though we are just as "at home" in the Garden District and the Faubourg Marigny (pronounced Foe-burg Mary-knee). And as an opportunity to wield influence, how much more

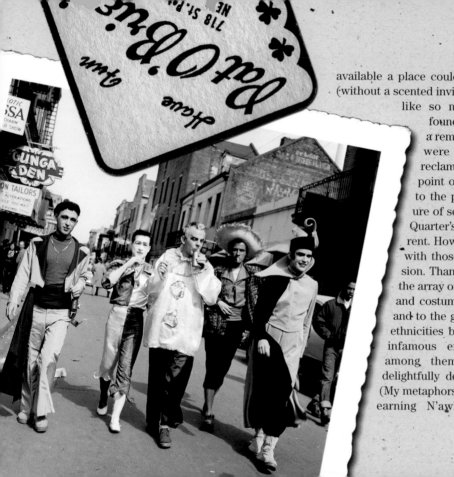

available a place could have been presented to us (without a scented invitation attached)? In any case, like so many areas we presumably found and fixed up, the Quarter is a remarkable achievement. And we were surely instrumental in its reclamation from decaying to the point of dissolution, too—but never to the point of forsaking that measure of seediness needed to evoke the Quarter's necessary sultry undercurrent. However, we must share triumph with those of a less *perverted* persuasion. Thanks must be given as much to the array of swashbucklers (of all colors and costumes) who "swished" onshore, and to the gumbo of diversity that many ethnicities brought to the pot, as to the infamous effete (Tennessee Williams among them) who illuminated "her" delightfully deviant and dim-lit corridors. (My metaphors are as mixed as the heritage earning N'awlins's diverse reputation!)

Additionally, our rediscovery would never have been enough to truly reclaim it, if others, more ably armed to do so, had not recognized the Quarter's value and protectively designated its easily limited borders.

Speaking of limitations, reins appear in the most unexpected places. In NOLA, even more shockingly so. With the feathery flamboyance of Mardi Gras, Halloween, and Southern Decadence, it comes as a shock to find that just a short while back such finery—in the form of female drag—was not allowed outside the Quarter. Nor outside the day of the actual events—even *inside* the Quarter. Yes, it was not legal for a man to don a dress in the most determinably decadent—and cross-dressing-crazed—spot in the country. Surprisingly, these restrictions held just to the edge of Orleans Parish. In next-door Jefferson, a guy could prance about in his petticoats in places like the touristy Club My-O-My. It was not until the '70s that a loosening of the ties that bind (the corseting, as it were) came about. Yes, my-o-my!

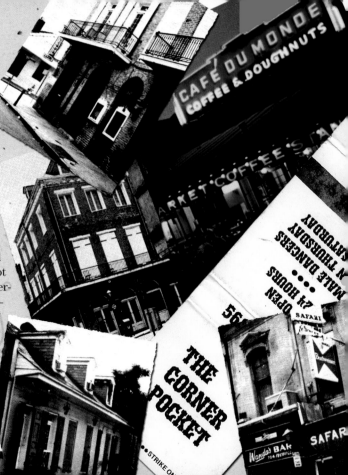

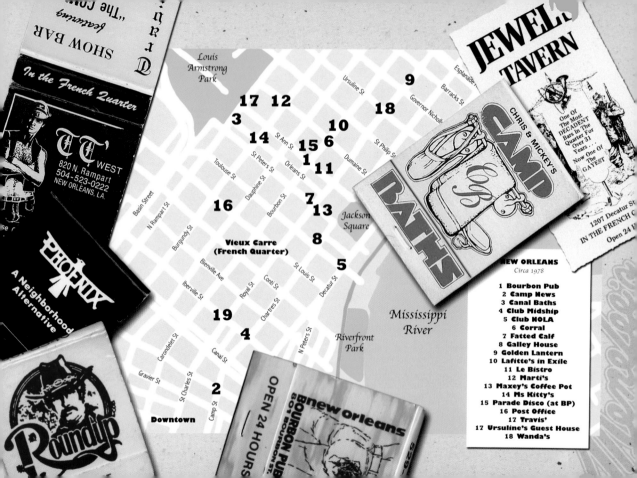

NEW ORLEANS
Circa 1978

1 Bourbon Pub
2 Camp News
3 Canal Baths
4 Club Midship
5 Club NOLA
6 Corral
7 Fatted Calf
8 Galley House
9 Golden Lantern
10 Lafitte's in Exile
11 Le Bistro
12 Marti's
13 Maxey's Coffee Pot
14 Ms Kitty's
15 Parade Disco (at BP)
16 Post Office
17 Travis'
17 Ursuline's Guest House
18 Wanda's

New York City

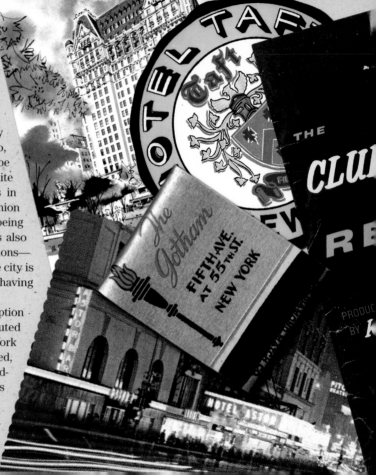

The Big Apple can be a very gay place. But queerly, not like San Francisco. The difference? A gay man is likely to live in Manhattan (sorry, other boroughs) for his career first. His sexuality might come second. But in San Francisco, those priorities could far more easily be reversed. Put another way, you can live quite "gaily" in New York, where occupations in retail, interior design, advertising, and fashion abound. But success would be solely for being a fashion designer, not as a gay one. It is also through these mainly white-collar professions—so unlike grimier blue-collar jobs—that the city is a fertile gay ground. Yet some view it as having been gayer in its grimier past.

This questionable perception comes from the undisputed reality that New York City has, indeed, become a cleaned-up version of its former "dirty" self.

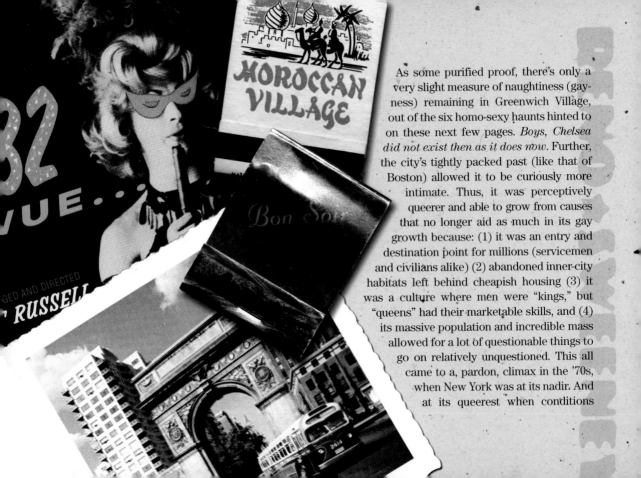

As some purified proof, there's only a very slight measure of naughtiness (gayness) remaining in Greenwich Village, out of the six homo-sexy haunts hinted to on these next few pages. *Boys, Chelsea did not exist then as it does now.* Further, the city's tightly packed past (like that of Boston) allowed it to be curiously more intimate. Thus, it was perceptively queerer and able to grow from causes that no longer aid as much in its gay growth because: (1) it was an entry and destination point for millions (servicemen and civilians alike) (2) abandoned inner-city habitats left behind cheapish housing (3) it was a culture where men were "kings," but "queens" had their marketable skills, and (4) its massive population and incredible mass allowed for a lot of questionable things to go on relatively unquestioned. This all came to a, pardon, climax in the '70s, when New York was at its nadir. And at its queerest when conditions

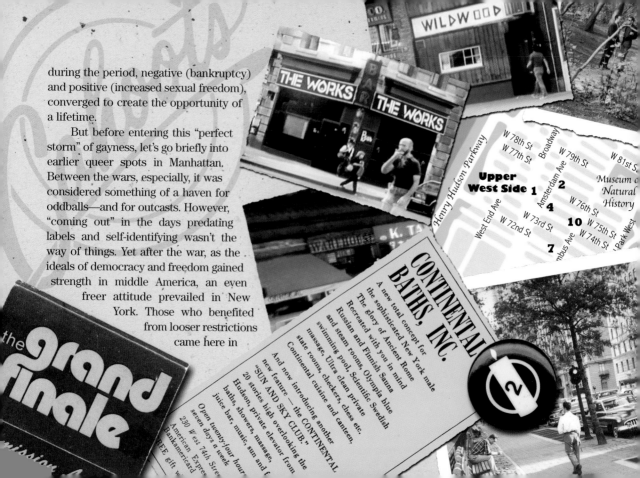

during the period, negative (bankruptcy) and positive (increased sexual freedom), converged to create the opportunity of a lifetime.

But before entering this "perfect storm" of gayness, let's go briefly into earlier queer spots in Manhattan. Between the wars, especially, it was considered something of a haven for oddballs—and for outcasts. However, "coming out" in the days predating labels and self-identifying wasn't the way of things. Yet after the war, as the ideals of democracy and freedom gained strength in middle America, an even freer attitude prevailed in New York. Those who benefited from looser restrictions came here in

CONTINENTAL BATHS, INC.

A new total concept for the sophisticated New York male

The glory of Ancient Rome Recreated with you in mind

Russian and Finnish Sauna and steam rooms. Olympia blue swimming pool. Scientific Swedish massage. Ultra clean private slate rooms, checkers, chess etc.

Continental cuisine and canteen.

And now introducing another new feature — the CONTINENTAL "SUN AND SKY CLUB." 20 stories high overlooking the Hudson, private elevator from baths, showers, massage, juice bar, music, sun and f...

Open twenty-four hour seven days a week 230 W 74th Stre... American Expre... BankAmericard FREE gift w...

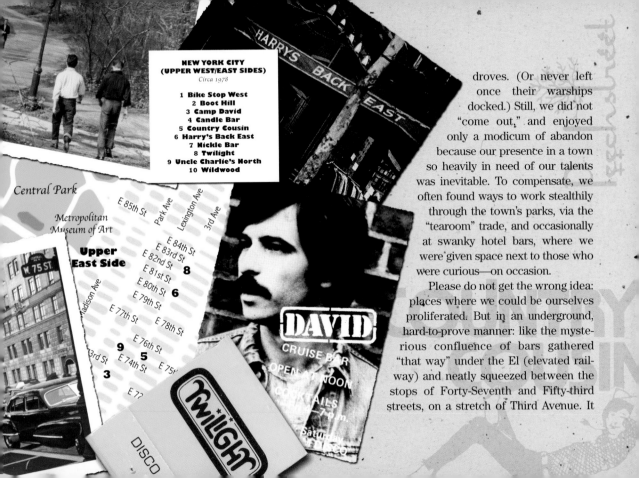

**NEW YORK CITY
(UPPER WEST/EAST SIDES)**
Circa 1978

1 Bike Stop West
2 Boot Hill
3 Camp David
4 Candle Bar
5 Country Cousin
6 Harry's Back East
7 Nickle Bar
8 Twilight
9 Uncle Charlie's North
10 Wildwood

Central Park

Metropolitan
Museum of Art

**Upper
East Side**

E 85th St
E 84th St
E 83rd St
E 82nd St **8**
E 81st St
E 80th St **6**
E 79th St
E 77th St E 78th St
E 76th St
9 E 74th St **5**
3 E 72

Park Ave
Lexington Ave
3rd Ave
Madison Ave
3rd St
W. 75 ST

DAVID
CRUISE BAR
OPEN AT NOON
COCKTAILS
7 p.m.
Saturday
DISCO

TWILIGHT
DISCO

droves. (Or never left once their warships docked.) Still, we did not "come out," and enjoyed only a modicum of abandon because our presence in a town so heavily in need of our talents was inevitable. To compensate, we often found ways to work stealthily through the town's parks, via the "tearoom" trade, and occasionally at swanky hotel bars, where we were given space next to those who were curious—on occasion.

Please do not get the wrong idea: places where we could be ourselves proliferated. But in an underground, hard-to-prove manner: like the mysterious confluence of bars gathered "that way" under the El (elevated railway) and neatly squeezed between the stops of Forty-Seventh and Fifty-third streets, on a stretch of Third Avenue. It

was infamously known as the "bird circuit," owing to the tourlike way we tried visiting all the establishments in a night and to their feathery names, Blue Parrot and the Swan, among them. (Gay bar/club names always seem to reflect current self-awareness. Hence, at the time we thought ourselves rather "flighty." By the '70s, with names like Ramrod and Spike, could our sexual aspirations have been any plainer?) With its nearness to Midtown jobs, gay men set up house throughout this immediate area, too. But by 1978 this romping ground was run out. An undeniable and intriguing cause: the late '50s removal of the railway exposed "shady" behavior. However, we did not altogether leave. Many businesses strung along and near Fifty-third Street, and by the time of disco it was a notorious stretch where "older" looked for "younger," often if the timing and price was right.

Another populace took hold in Times Square. But being at "the crossroads of the world" added a troublingly transient edge, and accounted for its high(er) ratio of "temporarily" gay types: hustlers and their patrons. Thanks to the theaters, though, it was

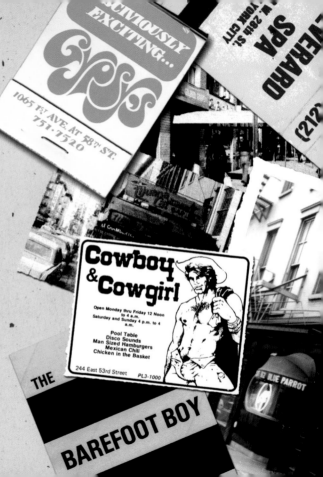

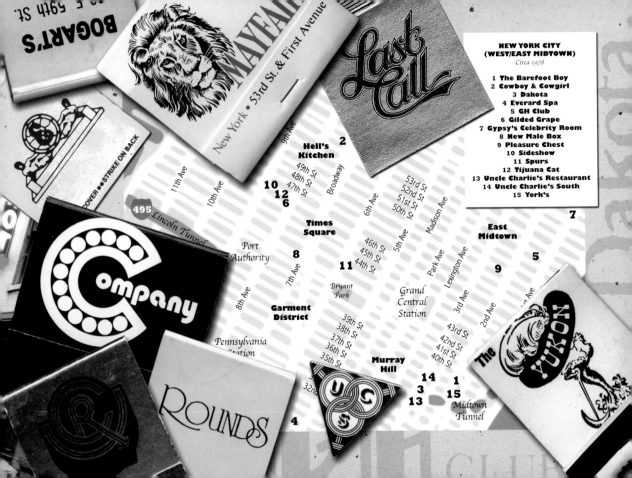

BOGART'S 129 E. 59th St.

MAYFAIR New York • 53rd St. & First Avenue

Last Call

STRIKE ON BACK · LOVER

Company

ROUNDS

The YUKON

NEW YORK CITY
(WEST/EAST MIDTOWN)
Circa 1978

1 The Barefoot Boy
2 Cowboy & Cowgirl
3 Dakota
4 Everard Spa
5 GH Club
6 Gilded Grape
7 Gypsy's Celebrity Room
8 New Male Box
9 Pleasure Chest
10 Sideshow
11 Spurs
12 Tijuana Cat
13 Uncle Charlie's Restaurant
14 Uncle Charlie's South
15 York's

11th Ave
10th Ave
9th Ave

Hell's Kitchen 2

49th St
48th St
47th St

Broadway

10
12
6

53rd St
52nd St
51st St
50th St

6th Ave
5th Ave

Madison Ave

495 Lincoln Tunnel

Times Square

Port Authority

8

7th Ave

8th Ave

46th St
45th St
44th St

Park Ave
Lexington Ave
3rd Ave
2nd Ave

East Midtown

5

9

7

11

Bryant Park

Grand Central Station

Garment District

39th St
38th St
37th St
36th St
35th St

43rd St
42nd St
41st St
40th St

Pennsylvania Station

Murray Hill

14 **1**
3 **15**
13

32nd St

UCS

Midtown Tunnel

4

enlivened with an actor/singer/dancer and waiter crowd who earned it the *supportive* nickname "the dance belt."

But the area's sleazy edge made it an unsuitable home. So, many chorus boys hoofed it up to the Upper West Side, where nicer single-room-occupancy dwellings were plentiful (in brownstones forsaken by former occupants). The area's palpable homomasculinity was as overwhelming as its decline is telling. Dozens of queer businesses opened successfully, including the Continental Baths, below street level at Seventy-fourth and Broadway, where Bette Midler and Barry Manilow got their start. Then, under the pressure of continual gentrification forces, we, along with those who "rambled" through the park nearby, blended back into the woodwork.

Once having had a near-equal stake on the Upper East Side is almost too much of a fairy's tale to believe. However, we did' and found low rents in this well-known high-toned

TRILOGY

ChristopherSt

DANNY'S
"The newest place to come"
★
39 Christopher St.
r. Greenwich St.
YORK CITY

UNCLE PAUL'S
ON CHRISTOPHER
NEAR GAY STREET

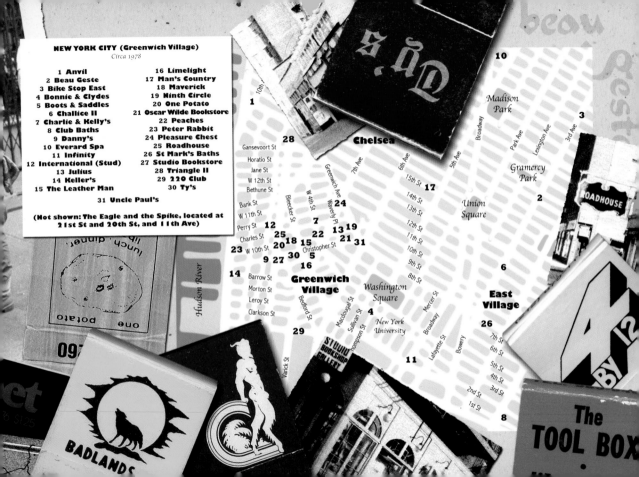

NEW YORK CITY (Greenwich Village)
Circa 1978

1 Anvil
2 Beau Geste
3 Bike Stop East
4 Bonnie & Clydes
5 Boots & Saddles
6 Challice II
7 Charlie & Kelly's
8 Club Baths
9 Danny's
10 Everard Spa
11 Infinity
12 International (Stud)
13 Julius
14 Keller's
15 The Leather Man

16 Limelight
17 Man's Country
18 Maverick
19 Ninth Circle
20 One Potato
21 Oscar Wilde Bookstore
22 Peaches
23 Peter Rabbit
24 Pleasure Chest
25 Roadhouse
26 St Mark's Baths
27 Studio Bookstore
28 Triangle II
29 220 Club
30 Ty's

31 Uncle Paul's

**(Not shown: The Eagle and the Spike, located at
21st St and 20th St, and 11th Ave)**

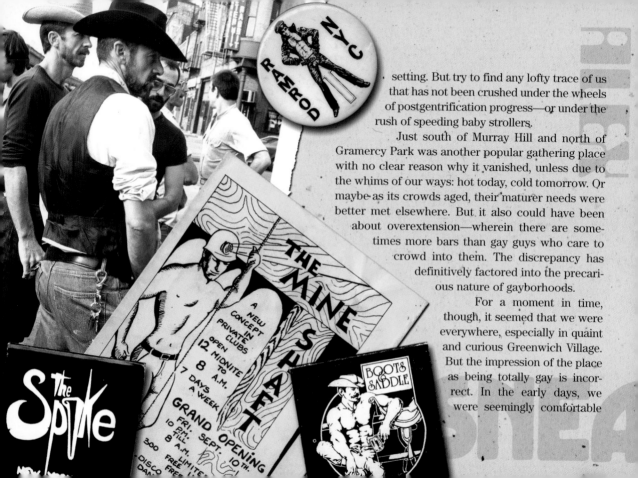

setting. But try to find any lofty trace of us that has not been crushed under the wheels of postgentrification progress—or under the rush of speeding baby strollers.

Just south of Murray Hill and north of Gramercy Park was another popular gathering place with no clear reason why it vanished, unless due to the whims of our ways: hot today, cold tomorrow. Or maybe as its crowds aged, their maturer needs were better met elsewhere. But it also could have been about overextension—wherein there are sometimes more bars than gay guys who care to crowd into them. The discrepancy has definitely factored into the precarious nature of gayborhoods.

For a moment in time, though, it seemed that we were everywhere, especially in quaint and curious Greenwich Village. But the impression of the place as being totally gay is incorrect. In the early days, we were seemingly comfortable

here because it was curiously "off," like its "queer" layout. But many artists and the arty, bohemians, and eccentrics are heterosexual, as well. So we were lumped in together. But sometimes we were cordoned off to our side of the room, literally and figuratively. This happened in the Bon Soir, a Village nightclub where, had it not been for us being there in the first place, one Ms. Barbra Streisand would likely not have made it so big. This kind of "separate togetherness" also explains why, depending on location, the Village was and was not as gay as one might have expected. Starting east from around Seventh Avenue, a neutering effect grew due to the heterosexual influences

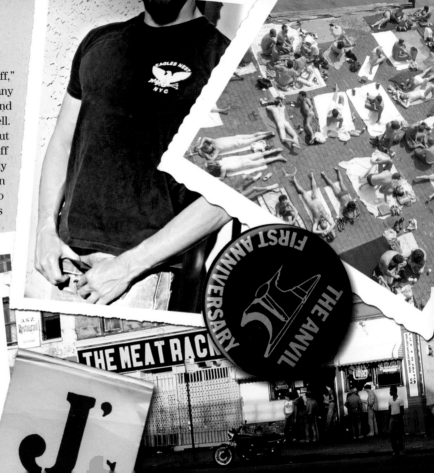

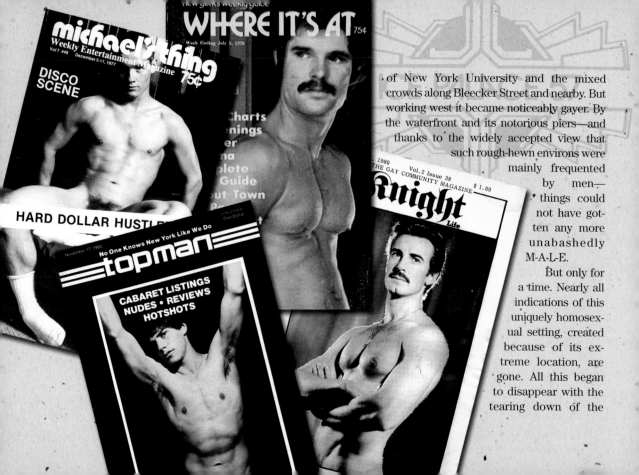

of New York University and the mixed crowds along Bleecker Street and nearby. But working west it became noticeably gayer. By the waterfront and its notorious piers—and thanks to the widely accepted view that such rough-hewn environs were mainly frequented by men—things could not have gotten any more unabashedly M-A-L-E.

But only for a time. Nearly all indications of this uniquely homosexual setting, created because of its extreme location, are gone. All this began to disappear with the tearing down of the

once-raised portion of the West Side Highway (for evidence, see title page photograph).

We find more "gay-to-gayer" trending working our way to the East Village. However, by the early '80s, savvy New Yorkers had become aware of the benefit of keeping in step with us: finders of areas on the verge, among other things. Thus, what was created in the East Village should be considered the first "gay-friendly" Big Apple neighborhood. But heading to Chelsea was an altogether different *gay*-venture. During the '70s, the area was a queer kind of place, but more of a pass-through than an actual place to stay. That changed as the spotlight on the historic value of the Village increased alongside its visible homosexuality. With the attention came a sharp rise in prices and a marked decrease in affordable living opportunities. Sound like a familiar pattern? By the end of the Village's gay "golden age," we

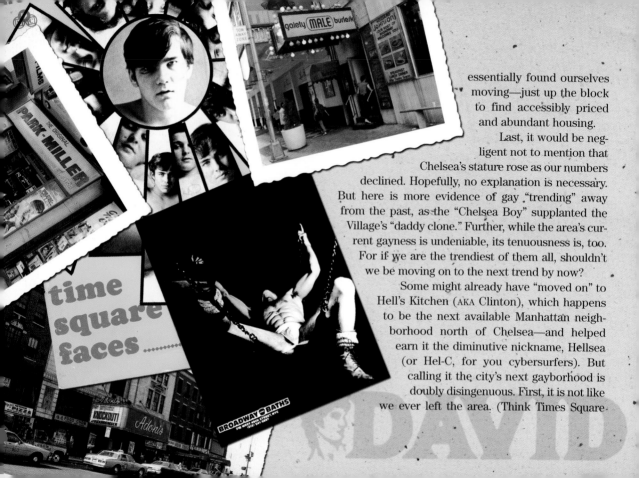

essentially found ourselves moving—just up the block to find accessibly priced and abundant housing.

Last, it would be negligent not to mention that Chelsea's stature rose as our numbers declined. Hopefully, no explanation is necessary. But here is more evidence of gay "trending" away from the past, as the "Chelsea Boy" supplanted the Village's "daddy clone." Further, while the area's current gayness is undeniable, its tenuousness is, too. For if we are the trendiest of them all, shouldn't we be moving on to the next trend by now?

Some might already have "moved on" to Hell's Kitchen (AKA Clinton), which happens to be the next available Manhattan neighborhood north of Chelsea—and helped earn it the diminutive nickname, Hellsea (or Hel-C, for you cybersurfers). But calling it the city's next gayborhood is doubly disingenuous. First, it is not like we ever left the area. (Think Times Square

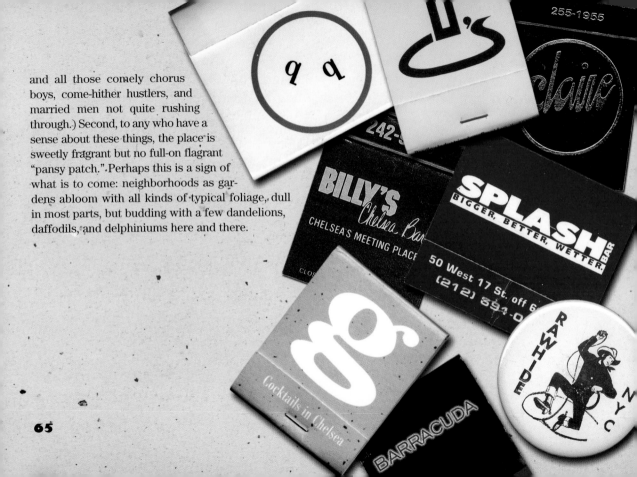

and all those comely chorus boys, come-hither hustlers, and married men not quite rushing through.) Second, to any who have a sense about these things, the place is sweetly fragrant but no full-on flagrant "pansy patch." Perhaps this is a sign of what is to come: neighborhoods as gardens abloom with all kinds of typical foliage, dull in most parts, but budding with a few dandelions, daffodils, and delphiniums here and there.

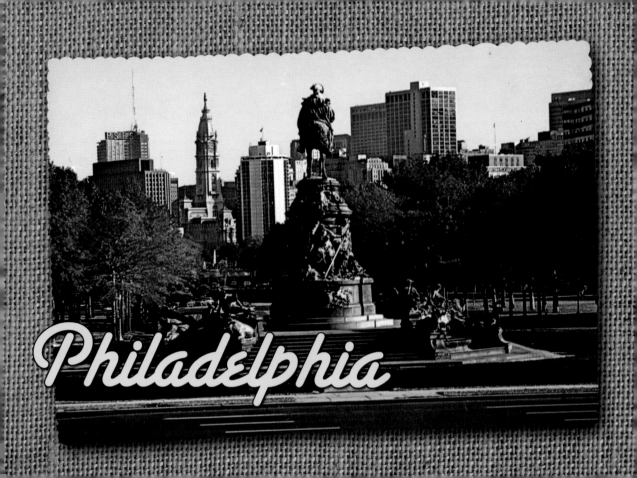

showing new Rittenhouse Apartment Bldg., Ph

HAPPY DAYS ARE HERE AGAIN...

Comprehending the totality of gay history is strangely elusive, mainly because we are a strangely elusive group. It is only through self-identifying and claiming space that we have made ourselves known and given our history the opportunity to be analyzed and recorded. But doing so is hardly once-and-for-all comprehensive. The ephemeral nature of our identity continues to make documentation specious. Be that as it may, for the short time of our reckoning (at most a couple of generations), it is mind-boggling how we have simplified things to three absolutes: (1) The modern-day "gay" turning point came in the wake of the events at Stonewall Inn (2) New York City's Greenwich Village (where Stonewall is located) was the first gay gathering place of sizable note and (3) San Francisco and the Castro are the gay meccas. Now, mention these to any Philadelphian knowledgeable about his city's queer past and you will get a rebuff that this is typical gay naïveté followed by a perception-shattering trio of reality checks: (1) picketers took to the steps of Philly's Independence Hall for the same gay freedoms three years prior to the fight

at Stonewall (2) their WashWest "gayborhood" boiled out of the same kind of bohemian brew that stirred up Greenwich Village (thanks mainly to the creative endeavors established there around the turn of the last century by unmistakably homoerotic artist Thomas Eakins) and (3) San Francisco and the Castro have the spotlight, but the city of "brotherly love" offers arguably as much intimate fraternal indulgence per square block in or out of the glare of those caring to look. So much for gay perception vs. queer truths.

This reflex is as justifiable as it is reflective of how we still find it necessary to take what is rightfully ours, because no one will hand it to us. And gay Philadelphians, often dismissed as living in New York City's "sixth borough," might always be forced to stand their ground against grabbier neighbors. But compared to flashier stones along the Atlantic seaboard (and with old-fashioned similarities to Boston), Philly offers a striking alternative to our so-called alternative lifestyle. A walk through its very manageably sized Center City makes this differ-

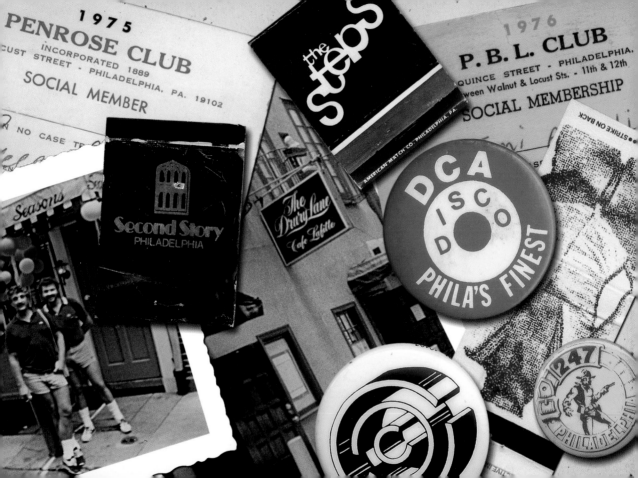

1975

PENROSE CLUB

INCORPORATED 1889

...CUST STREET · PHILADELPHIA, PA. 19102

SOCIAL MEMBER

... NO CASE T...

Seasons

Second Story
PHILADELPHIA

the **steps**

AMERICAN MATCH CO · PHILADELPHIA PA.

The *Drury Lane*
Cafe Lafitte

1976

P. B. L. CLUB

QUINCE STREET · PHILADELPHIA.
...ween Walnut & Locust Sts. · 11th & 12th

SOCIAL MEMBERSHIP

STRIKE ON BACK

DCA
DISCO
PHILA'S FINEST

247
PHILADELPHIA

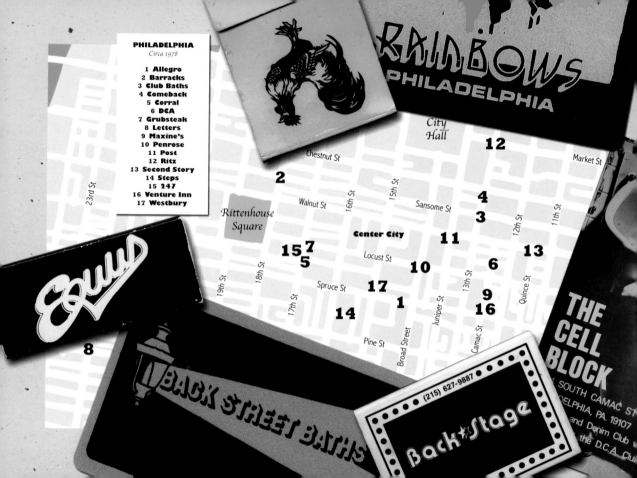

PHILADELPHIA
Circa 1978

1 Allegro
2 Barracks
3 Club Baths
4 Comeback
5 Corral
6 DCA
7 Grubsteak
8 Letters
9 Maxine's
10 Penrose
11 Post
12 Ritz
13 Second Story
14 Steps
15 247
16 Venture Inn
17 Westbury

RAINBOWS
PHILADELPHIA

THE
CELL
BLOCK

(215) 627-9887

BackStage

BACK STREET BATHS

Equus

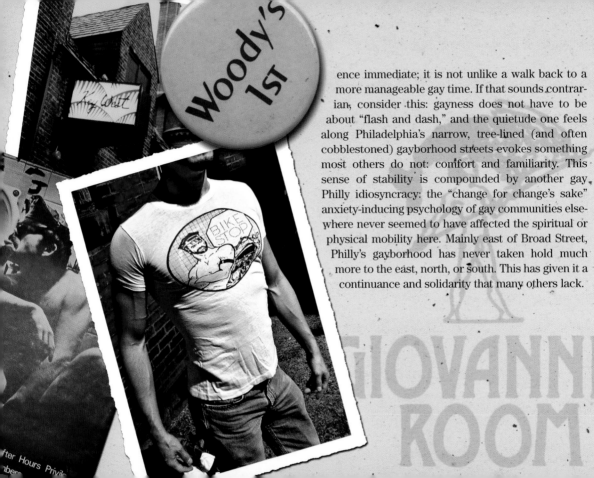

ence immediate; it is not unlike a walk back to a more manageable gay time. If that sounds contrarian, consider this: gayness does not have to be about "flash and dash," and the quietude one feels along Philadelphia's narrow, tree-lined (and often cobblestoned) gayborhood streets evokes something most others do not: comfort and familiarity. This sense of stability is compounded by another gay Philly idiosyncracy: the "change for change's sake" anxiety-inducing psychology of gay communities elsewhere never seemed to have affected the spiritual or physical mobility here. Mainly east of Broad Street, Philly's gayborhood has never taken hold much more to the east, north, or south. This has given it a continuance and solidarity that many others lack.

San Diego

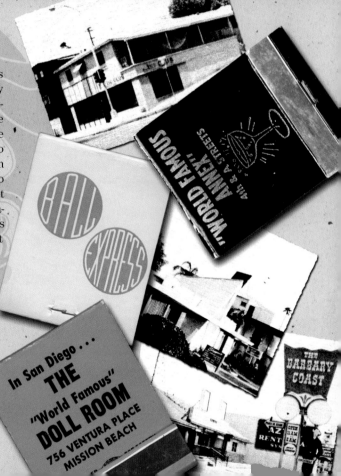

nescapably, San Diego is a harbor town. This is something the American armed forces, especially the navy, took note of. Which brings up a very titillating reason why a gay presence is stronger in some places and weaker in others. But only if you believe that sailors are the most inclined of all servicemen to act out sexually—and the least inclined to care whom with. The premise is difficult to verify (though who wouldn't like to do some hands-on research?). Yet there is no denying that a seaman's access to assignations, with his constant docking in and out of ports, is verifiably greater than his brothers-in-arms. It is most curious, though, that these occurrences have often gone on surely with military command's knowledge, particularly in San Diego, where bathhouses (those places for the obvious and the not-so to exchange far more than passing glances) once abounded near the waterfront. Their indifference could be read as acceptance. At least of the inevitability of a man's needing to have his sexual desires sated by whatever means available.

A testosterone-heavy and heavily transient male population will often use the "they

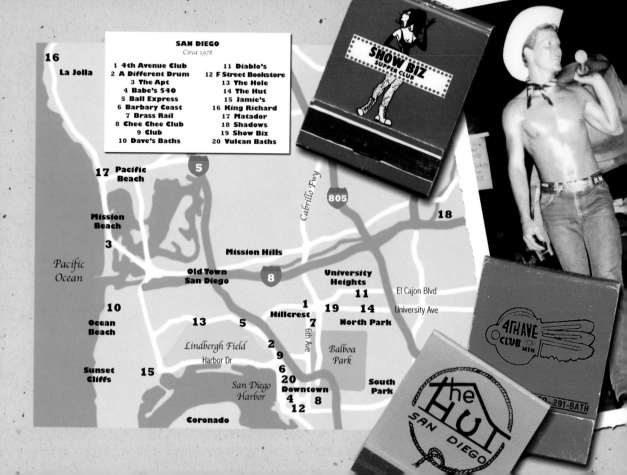

SAN DIEGO
Circa 1978

1 4th Avenue Club
2 A Different Drum
3 The Apt
4 Babe's 540
5 Ball Express
6 Barbary Coast
7 Brass Rail
8 Chee Chee Club
9 Club
10 Dave's Baths
11 Diablo's
12 F Street Bookstore
13 The Hole
14 The Hut
15 Jamie's
16 King Richard
17 Matador
18 Shadows
19 Show Biz
20 Vulcan Baths

16
La Jolla

17 Pacific
Beach

Mission
Beach

3

Pacific
Ocean

5

Cabrillo Fwy

805

18

Mission Hills

Old Town
San Diego

8

University
Heights

El Cajon Blvd

University Ave

11

10

Ocean
Beach

13

5

1

Hillcrest

7

19

14

North Park

Sunset
Cliffs

15

Lindbergh Field

Harbor Dr

2

9

6

20

Downtown

4

12

8

6th Ave

Balboa
Park

South
Park

San Diego
Harbor

Coronado

SHOW BIZ
SUPER CLUB

4TH AVE
CLUB FOR MEN

-291-BATH

the HUT
SAN DIEGO

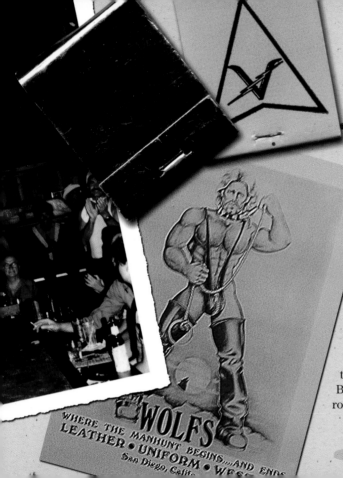

will never see me again" excuse to find their way to satisfaction, too. This gives San Diego's scene an especially saucy subversiveness, as these urges have, for a long while, been put to good use as nameless (or porn-named) "numbers" in the town's prolific production of explicitly gay sexual materials. Surely the community could not resist, in many good—and bad-boy—ways, its aquatic connections. A look at the map shows how in 1978 it hugged the shore. But transition was under way. By then, fewer sailors were arriving, and consternation was increasing over our intermingling—in the baths and the bars, parks, rest rooms, and streets closeby.

But aside from occasionally retreating to the "fruit bowl" beach at La Jolla, where was gay San Diego going? How about up on the "crest" of the nearest hill, to a middle-class neighborhood called Hillcrest! You might notice that to get there you have to cross a freeway, too. But what you might not have seen is that another road, the Mission Freeway, was the cause for turn-

WOLFS

WHERE THE MANHUNT BEGINS...AND ENDS

LEATHER • UNIFORM • WE

San Diego, Calif.

ing things our way. Now, this highway did not take residents away so much as it gave them a shopping option. Yes, the "call of the mall" was the original area's death knell, as once-thriving Hillcrest retailers succumbed to having customers find the greater availability of consumer goods over the other side of the hill's crest. As they shuttered, homeowners followed, leaving many an empty bungalow—near many an onshore ship's crew member and oh-so-cruisy Marston Point in Balboa Park. There you have it—and remember what can happen as a result of undergoing "retail therapy" at your local shopping center.

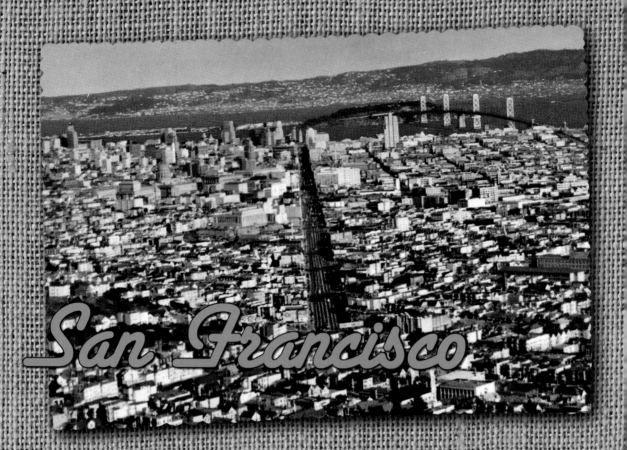

San Francisco

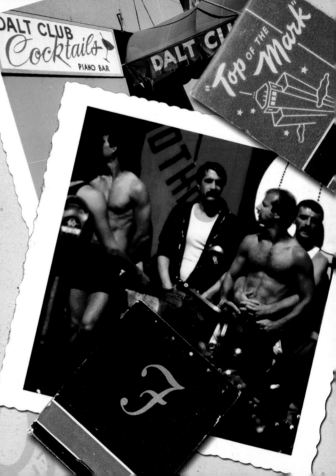

Do you think you know everything gay about the City by the Bay? I did, until I found that there is much more to queer San Francisco than that beloved spot called the Castro. This in no way means to denigrate the place's sanctity, merely to put it into the eye-opening perspective that comes from finding out there's more to any story than meets the eye.

To wit, San Francisco's gayness can be traced back to its bawdy gold-rush days and the loose lifestyle its far-from-home settlers enjoyed. Being that everyone was from somewhere else allowed people to essentially start their lives over—without the taint of a troubling past. Historians consider this dynamic—strongly evident in San Francisco—key to our queer emergence. Further, while all seaports (must) admit to some homomasculine interaction, thanks to the noted randiness of sailors, for many it was as fleeting as the arrival and departure of "Fleet Week." But in San Francisco, this aspect stayed permanently on dry land.

To these Pacific shores in multitudes we then came, and helped to make them into a most civi-

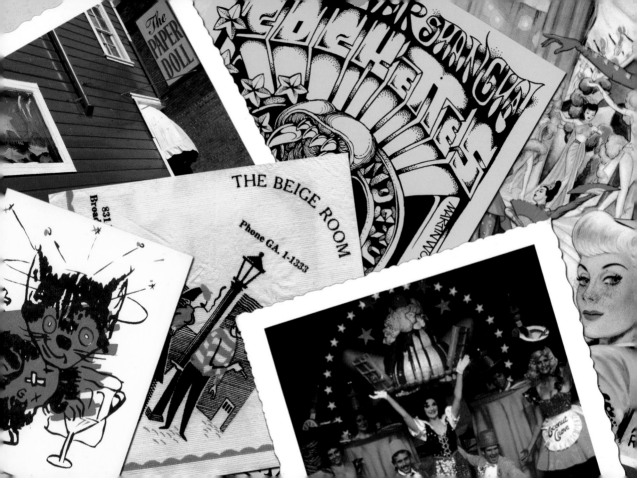

lized place. Not surprisingly, we were also experts in what many deemed the most depraved activities. And this behavior did flourish in social scenes (bars, brothels, and baths) that formed the basis for our budding community through the 1930s. But such interaction increased during World War II, and after, upon our realizing that nowhere else seemed as welcoming—especially to the many homosexuals dishonorably discharged, who knew that back in the boonies a rather unpleasant "welcome home" awaited them.

They started a wave that was the beginning of our modern-day rise. But even with this gaily auspicious start, there have been moments of extreme tension, as when the military, sensing too many were heading astray, forbade personnel from going inside questionable onshore businesses. You can be sure which ones were on that list (and thanks to the armed forces for creating the first "gay" bar guide in American history!).

However, while the tone of these many dives was rather obvious, they existed in a time when "that" was an assumption. By the early '60s, barkeeps had had enough of the ambiguity that allowed for others to take ill advantage by way of bribery, raids, and general harassment. Unlike absentee owners, self-proprietorship meant they had a more personal stake in the success and failure of each business, too. They banded together as the Tavern Guild, and contested the illegality of waiting on us in a direct manner. Their winning the right to do so really kicked San Francisco on its "Mary" way.

Why would this have had such a monumental impact? The answer turns out to be another key to the *queer*-ifying of San Francisco. It wasn't just bar owners

1434-1438
UPPER GRANT
SAN FRANCIS

PLEASE CLOSE COVER BEFC

527 CLUB

Off The Levee

527 BRYANT
N FRANCISCO

suddenly being allowed to serve whom they wanted; these establishments were now going to be identifiable as those catering to a quite distinct clientele. Further, this gave patrons, individually and as a group, something they had not experienced: identity and the power that goes with it. In turn, with this new presence, of mind and body (and spirit), more claims were made that culminated in our "sticking a flag" (of course rainbow-colored) in the Castro.

But we mustn't skip other milestones that most, even many native San Franciscans, are barely aware of in the journey there. We begin along the bayside's Embarcadero, where the first successful "gay" bars opened in the 1930s.

Then on to the North Beach area, where, during the war years—WWII through Vietnam—(and including parts once famously referred to as the Barbary Coast), it was an unparalleled adult entertainment district. Among the many sex-oriented businesses were many venues where the sex of the talent was the mystery attraction. Next we go Downtown and to Union Square. These business and shopping districts, like those in other cities, never came close to having a gay identity, and yet had their fair share of businesses that were gay. As was often the case, though, you

had to look up(stairs) and down(stairs) to find them. Or in some places you would get a whiff that something was amiss where the air was heavy with an oak wood scent. But you had to have a nose for sniffing "out" that sort of thing.

Farther west, in the Tenderloin, the smell could be quite pungent, thanks to years of wallowing in hard times (and winos). Yet the poverty that kept most away invited others in for a moment, or longer, in its many humbled abodes. As transient neighborhoods go, this one remains unique. Many pass it by, but a great number of "passing" individuals have made it their disenfranchised home—in a city that aspires to "diss" no one.

Next is likely the only other San Francisco gayborhood known outside of the city, South of Market, which had a physicality that lent itself to a particular life "style." And

to a point so pronounced it gratefully questioned the essence of gayness. As we became better self-aware, in the mid-'60s, acknowledgment that the then-popular definition of the gay male as feminine wholly ignored the extreme masculine aspects of many. So overwhelmingly obvious was this aggressive sexuality, from those once all assumed to be passive, that their presence became emblematic—and most evident down the "Miracle Mile" length of Folsom Street. Unfortunately, as the need to make known our manliness has lessened, in these times of acceptance, even urban renewal—and through the devastating forces of HIV—displays of this archetype have dwindled significantly.

You may contemplate that as we work our way over to a place widely considered the first true post-Stonewall gayborhood in the country. Constituting the

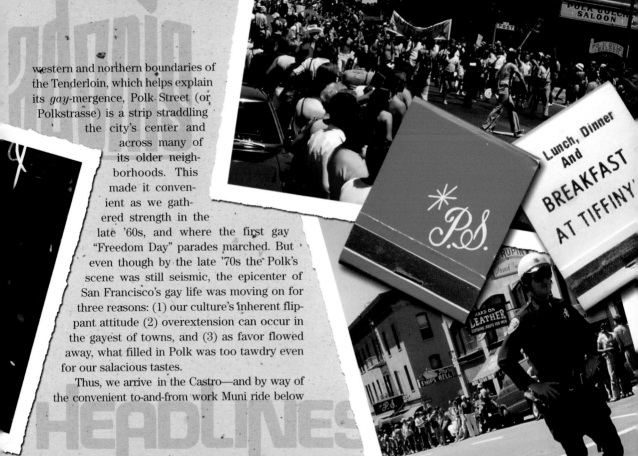

western and northern boundaries of the Tenderloin, which helps explain its *gay*-mergence, Polk Street (or Polkstrasse) is a strip straddling the city's center and across many of its older neighborhoods. This made it convenient as we gathered strength in the late '60s, and where the first gay "Freedom Day" parades marched. But even though by the late '70s the Polk's scene was still seismic, the epicenter of San Francisco's gay life was moving on for three reasons: (1) our culture's inherent flippant attitude (2) overextension can occur in the gayest of towns, and (3) as favor flowed away, what filled in Polk was too tawdry even for our salacious tastes.

Thus, we arrive in the Castro—and by way of the convenient to-and-from work Muni ride below

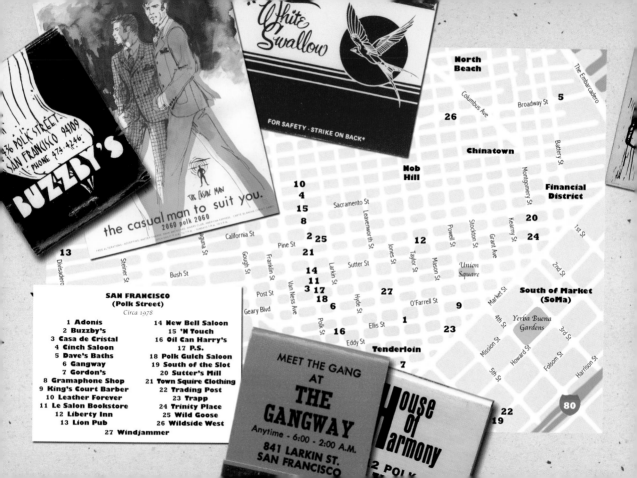

BUZZBY'S

2?6 POLK STREET
SAN FRANCISCO 94109
PHONE 474-4246

the casual man to suit you.
2060 polk 2060

THE CASUAL MAN

White Swallow

FOR SAFETY · STRIKE ON BACK*

North Beach

Columbus Ave
Broadway St

5

26

Chinatown

Nob Hill

The Embarcadero

Battery St

Financial District

Montgomery St

Kearny St

20

24

1st St

10
4
15
8

Sacramento St

2 25

21

Leavenworth St

Powell St

Stockton St

Grant Ave

Union Square

Market St

2nd St

South of Market (SoMa)

14
11
3 17
18
6

California St

Pine St

Sutter St

Jones St

Taylor St

Mason St

27

O'Farrell St

9

Yerba Buena Gardens

3rd St

Van Ness Ave

Post St

Geary Blvd

Hyde St

Ellis St

1

23

4th St

Mission St

Howard St

Folsom St

Harrison St

5th St

16

Eddy St

Tenderloin

7

80

Steiner St

Divisadero

13

Laguna St

Gough St

Franklin St

Bush St

Polk St

Larkin St

SAN FRANCISCO
(Polk Street)
Circa 1978

1 **Adonis**	14 **New Bell Saloon**
2 **Buzzby's**	15 **'N Touch**
3 **Casa de Cristal**	16 **Oil Can Harry's**
4 **Cinch Saloon**	17 **P.S.**
5 **Dave's Baths**	18 **Polk Gulch Saloon**
6 **Gangway**	19 **South of the Slot**
7 **Gordon's**	20 **Sutter's Mill**
8 **Gramaphone Shop**	21 **Town Squire Clothing**
9 **King's Court Barber**	22 **Trading Post**
10 **Leather Forever**	23 **Trapp**
11 **Le Salon Bookstore**	24 **Trinity Place**
12 **Liberty Inn**	25 **Wild Goose**
13 **Lion Pub**	26 **Wildside West**
	27 **Windjammer**

MEET THE GANG
AT
THE GANGWAY
Anytime - 6:00 - 2:00 A.M.
841 LARKIN ST.
SAN FRANCISCO

House
of
Harmony

2 POLK

Market Street! Even so, getting here was not easy, as some of us expect nowadays. Notably the first bar in the area, the Missouri Mule, set itself down on Market in 1963, just one year after the first leather bar opened in SoMa. Castro Street was still in the throes of trending out its largely Irish immigrant population. And those heading in were a decidedly "heady" lot, given to getting high and more hippie than typically gay hip. This point begs further exposition. In the '70s, when SoMa, Polk, and the Castro were popular, each took on a leather, dressy, or Levi's crowd. The latter's jean-cladding belies the deliberately laid-back air that grew here as the decade "wore" to a close. It culminated in the "Castro Clone," a gay icon who, through his casual yet masculine attire,

89

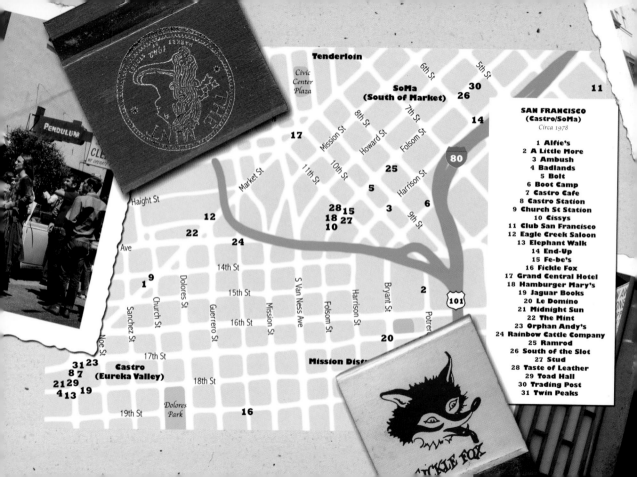

Tenderloin

Civic Center Plaza

SoMa (South of Market)

6th St

5th St

30

26

11

14

PENDULUM

8th St

7th St

Mission St

Howard St

Folsom St

80

17

Market St

11th St

10th St

25

5

Harrison St

3

6

Haight St

28 15

18 27

10

9th St

12

22

24

Ave

14th St

9

15th St

S Van Ness Ave

2

101

Dolores St

Church St

Guerrero St

16th St

Mission St

Folsom St

Harrison St

Bryant St

Potrero

20

Sanchez St

Noe St

17th St

Castro (Eureka Valley)

Mission District

31 23

8 7

21 29

4 13 19

18th St

16

19th St

Dolores Park

FICKLE FOX

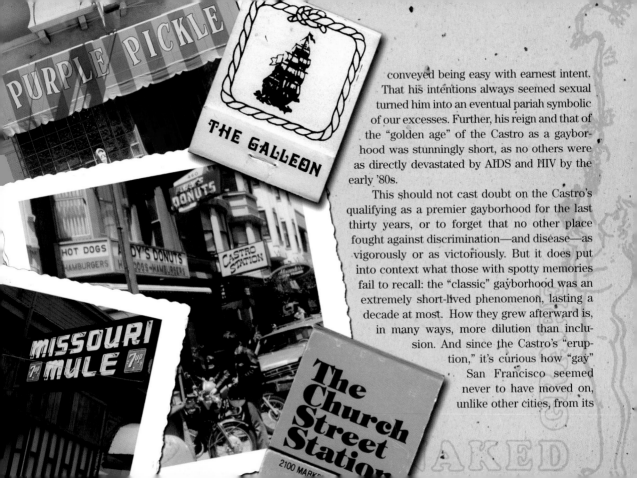

conveyed being easy with earnest intent. That his intentions always seemed sexual turned him into an eventual pariah symbolic of our excesses. Further, his reign and that of the "golden age" of the Castro as a gayborhood was stunningly short, as no others were as directly devastated by AIDS and HIV by the early '80s.

This should not cast doubt on the Castro's qualifying as a premier gayborhood for the last thirty years, or to forget that no other place fought against discrimination—and disease—as vigorously or as victoriously. But it does put into context what those with spotty memories fail to recall: the "classic" gayborhood was an extremely short-lived phenomenon, lasting a decade at most. How they grew afterward is, in many ways, more dilution than inclusion. And since the Castro's "eruption," it's curious how "gay" San Francisco seemed never to have moved on, unlike other cities, from its

volcanic center. This can leave reading the Castro's present-day sexual orientation as active, dormant, or extinct. Or perhaps because this 'hood exists in a city that prides itself on being accepting of all things queer, then keeping steady instead of constantly blowing its stack may just be the Castro's chosen course of late. And why lose your cool if you don't have to?

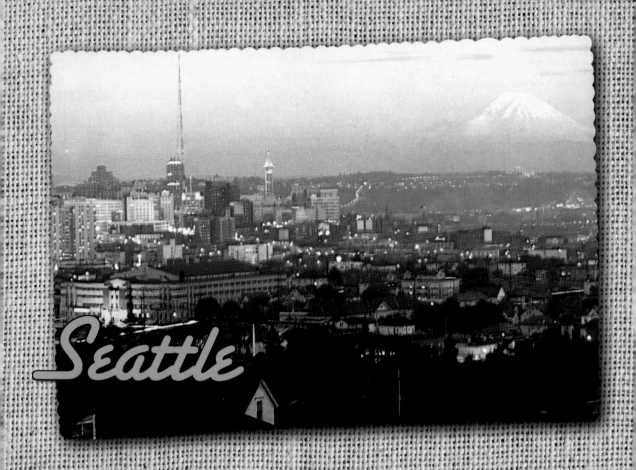

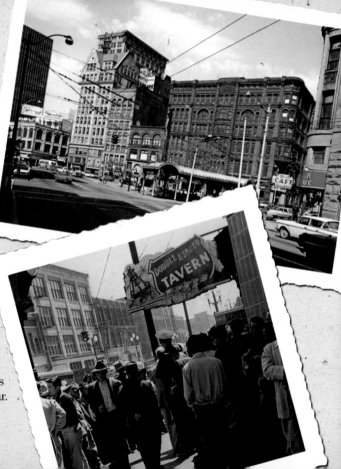

This, the "emerald city" with its lasting impressions of cultural, architectural, and social modernity and diversity, is definitely a place of the "new world order." To the contrary, though, it is still easy to see Seattle's "roots"— in the deep forestation that envelops it and that brought mainly men here in the first place. This kind of absolute maleness also informed Seattle's coming gayness. In the frontier, largely without the companionship of women and the moral restrictions held back in the civilized East, men made do by getting rather wild with each other while taming the wild Pacific Northwest. Thus, this aspect of male outpost mentality greatly influenced present-day Seattle men to behave as they would want to, naturally. (Get me my plaid shirt, boots, and thermal underwear, guys; I'm ready to move!)

Seattle's male-dominated beginnings coupled with its harbor geography further compelled its gay community to grow. The city's port was always awash with men—especially during times of war.

And often, with little time available, and plenty of mortal thoughts in mind, many of these guys chose, like those who had before them, to act on pure erotic impulse.

As in San Diego, the chances to cross paths with other men near the waterfront was stupendous. But our presence was just as notable in Pioneer Square, an area which had, by the 1950s, become Seattle's skid row—and, naturally, a gay bar district—as the commercial center of town moved north. Interestingly, we were tolerated here as long as we paid off "bad" police and while the place was ignored by the good people of Seattle. And they did leave matters well enough alone—until the 1962

The FOX And HOUNDS

the SC

Marine Room

THE MOCAMBO
Pioneer Square-Olde Seattle
203 Yesler Way
682~~4627

The 614

Guest Card

IN SEATTLE, IT'S THE
DIKE ST.
TAVERN

THE
611
611 - 2nd AVE.
SEATTLE, WASH.

2024
TAVERN
·
2024 Westlake Ave.
Seattle, Wash.

ARENA

the COLUM

DOG HOUSE

BUTCH

Bob Mur

A-2741

Bob Mur

World's Fair put the entire city on the map. Soon after, Pioneer Square's restoration was in order, and presentable businesses were encouraged to take over space occupied by far less presentable ones. Curiously enough, this crossing over set into motion the eventual rise of Seattle's gayborhood, as many of the square's new tenants (designers, decorators, and gallery owners) left space in Capitol Hill, just east of downtown, and triggered a downturn in that neighborhood. Conversely, a number of displaced barkeeps took over many of their vacated locations.

But this turnover did not happen overnight. It was a slow process (unlike today's developers' instant neighborhoods) and one look at the 1978 map indicates that even by the late '70s most "hot spot" activity was happening elsewhere. Regardless, Capitol Hill was a natural gay setting that was close to the city's center (reached easily by crossing an expressway); filled with large homes to rent, buy, and sometimes divide into gay commune-type housing; bounded by two well-regarded universities; and edged with beautiful and densely forested Volunteer Park.

98

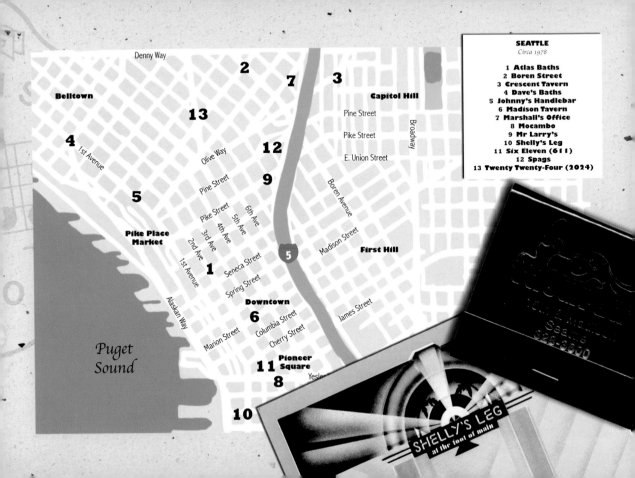

SEATTLE
Circa 1978

1 Atlas Baths
2 Boren Street
3 Crescent Tavern
4 Dave's Baths
5 Johnny's Handlebar
6 Madison Tavern
7 Marshall's Office
8 Mocambo
9 Mr Larry's
10 Shelly's Leg
11 Six Eleven (611)
12 Spags
13 Twenty Twenty-Four (2024)

Denny Way

Belltown

Capitol Hill

Pine Street

Pike Street

Broadway

E. Union Street

1st Avenue

Olive Way

Pine Street

Pike Place
Market

Pike Street

6th Ave

5th Ave

4th Ave

3rd Ave

2nd Ave

Boren Avenue

Madison Street

First Hill

1st Avenue

Seneca Street

Spring Street

Alaskan Way

Downtown

Puget
Sound

Marion Street

Columbia Street

Cherry Street

James Street

Pioneer
Square

Yesler

SHELLY'S LEG
at the foot of main

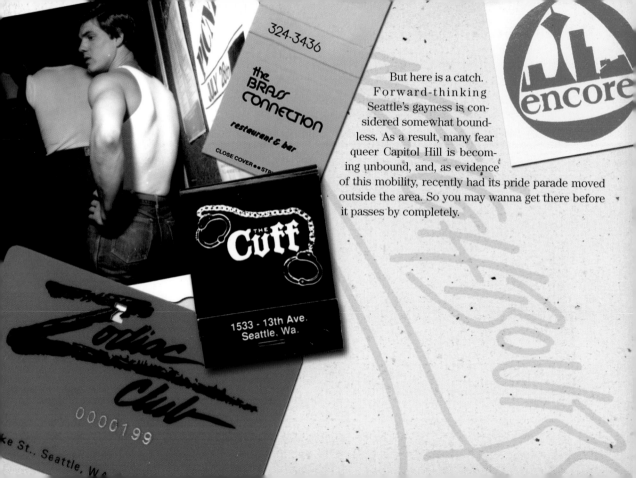

324-3436

the
BRASS
CONNECTION

restaurant & bar

CLOSE COVER ●● STR

encore

THE
Cuff

1533 - 13th Ave.
Seattle. Wa.

Zodiac
Club

0000199

ke St.. Seattle, W

But here is a catch. Forward-thinking Seattle's gayness is considered somewhat boundless. As a result, many fear queer Capitol Hill is becoming unbound, and, as evidence of this mobility, recently had its pride parade moved outside the area. So you may wanna get there before it passes by completely.

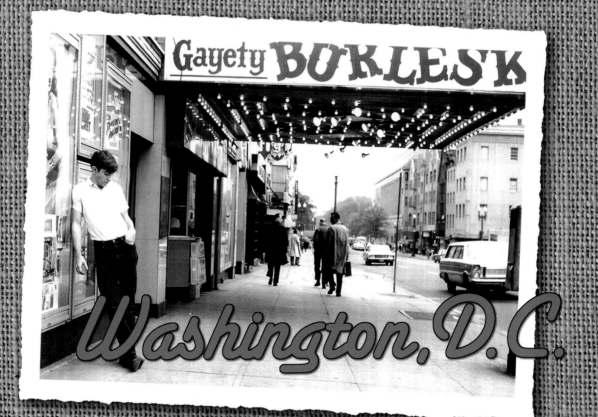

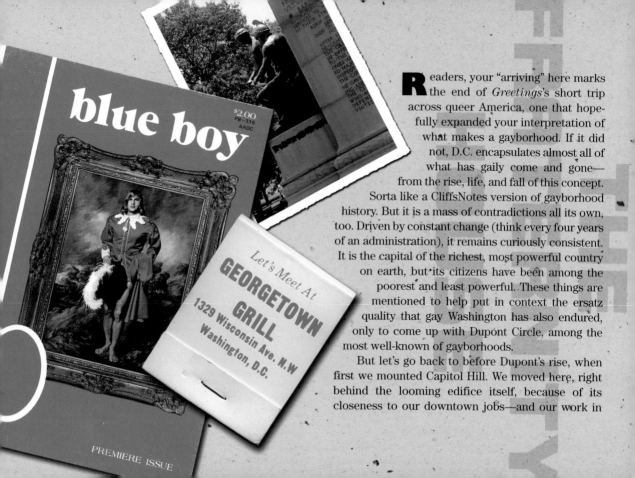

blue boy

$2.00
PB-316
AADC

Let's Meet At
GEORGETOWN GRILL
1329 Wisconsin Ave. N.W
Washington, D.C.

PREMIERE ISSUE

Readers, your "arriving" here marks the end of *Greetings*'s short trip across queer America, one that hopefully expanded your interpretation of what makes a gayborhood. If it did not, D.C. encapsulates almost all of what has gaily come and gone— from the rise, life, and fall of this concept. Sorta like a CliffsNotes version of gayborhood history. But it is a mass of contradictions all its own, too. Driven by constant change (think every four years of an administration), it remains curiously consistent. It is the capital of the richest, most powerful country on earth, but its citizens have been among the poorest and least powerful. These things are mentioned to help put in context the ersatz quality that gay Washington has also endured, only to come up with Dupont Circle, among the most well-known of gayborhoods.

But let's go back to before Dupont's rise, when first we mounted Capitol Hill. We moved here, right behind the looming edifice itself, because of its closeness to our downtown jobs—and our work in

the government. Convenient? Definitely. But be mindful of Washington's flippancy. During the '50s, something called the "lavender scare"—a nasty bit of homophobic rhetoric that claimed we were unsuited to government work because the illegality (and shame) of our orientation would lead to us being easily blackmailed into revealing national secrets—cost many thousands their jobs and forced many to leave town. But others stayed, solidifying our presence on the Hill. However, at that time we did so in rather subliminal ways, which would take a keen eye to uncover today. Fortunately, taking a walk down the once-prominent gay promenade, Eighth Street, still has clues to reveal. In due time you will pass in front of a barracks. Farther on, after passing under a highway, you will end up in the Navy Yards. Would any other evidence make it as obvious as to why we came here to begin with—and not somewhere else?

Now about those Navy Yards. They were not much more than a queer companion to Capitol Hill while it was a popular hangout. But as the entire area's fortunes began to diminish, it stayed, in a twist, a center of attraction. That is because

here, into big vacated structures, many a large venue opened, queer included. Unfortunately, in the years since, all have been pushed out in favor of further redevelopment—sports-minded, of all things!

Meanwhile, downtown Washington was aflutter. This was shocking to imagine now that every sign of same-sex activity has been removed and how such naughtiness happened to occur right by Pennsylvania Avenue, the broad, heavily tourist-trod street running from the Capitol to the White House. Just more of D.C.'s dual existence. For another example, Lafayette Square, a minute park where we very often found sly ways to play, sits right behind the White House!

Notably, not too far north of this gaily erotic statue-filled plot of greenery was the round intersection where gay Washington really came out to play, live, and work in the open. Coincidentally, our move to this rise (where things had sunk low) coincided with that of the "love thy neighbor" generation. And frankly, no one cared to

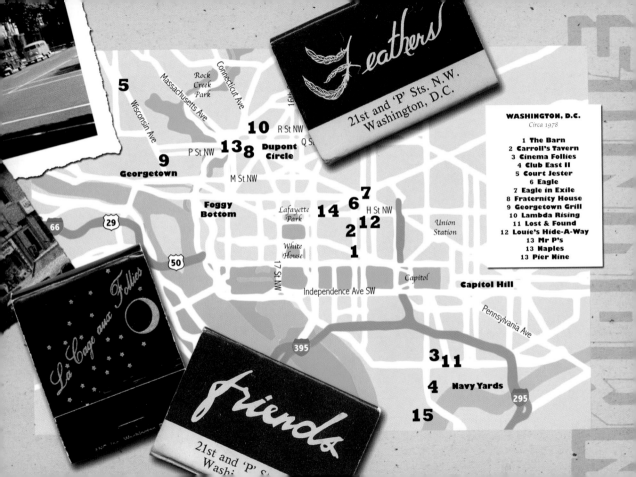

Feathers
21st and 'P' Sts. N.W.
Washington, D.C.

5

Rock Creek Park

Connecticut Ave

Massachusetts Ave

Wisconsin Ave

10 R St NW

13 8 Q St

P St NW Dupont Circle

9
Georgetown

M St NW

Foggy Bottom

Lafayette Park

14 7
6 H St NW
12
2
1

White House

17 St NW

WASHINGTON, D.C.
Circa 1978

1 The Barn
2 Carroll's Tavern
3 Cinema Follies
4 Club East II
5 Court Jester
6 Eagle
7 Eagle in Exile
8 Fraternity House
9 Georgetown Grill
10 Lambda Rising
11 Lost & Found
12 Louie's Hide-A-Way
13 Mr P's
13 Naples
13 Pier Nine

Union Station

Capitol

Capitol Hill

Independence Ave SW

Pennsylvania Ave

66 29 50

La Cage aux Follies

395

3 11

4 **Navy Yards**

15

295

friends
21st and 'P' S
Wash

push either of us out of Dupont Circle. But we found spots (spokes really, considering) to gravitate toward pretty much on our own. One was another early promenade, P Street. This was where those in constant search of fun times (of what kind, you should not need to ask) could take things a step further by walking across a divide, Rock Creek Park, that beheld down in the ravine our "Black Forest." And things needing a dark covering did all too often happen here. Things got even "funnier" on the other side. Many worked their way over to popular Georgetown Grill. Others "worked the square" (Dumbarton, that is), until residents nearby (Henry Kissinger among them), finding our idea of fun offensive, asked us to move along.

Returning to the round, we went in other directions as well. But also in a way that put a strain on the area's gay energy. Just east, but measurably so, another length of businesses formed a walk. Today, the strip is gayer than the circle that spawned it. This is an example of gayness that is "of" a place, but not what the place

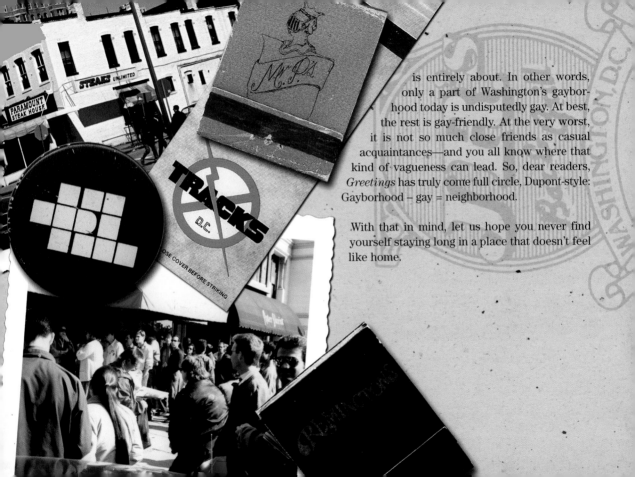

is entirely about. In other words, only a part of Washington's gayborhood today is undisputedly gay. At best, the rest is gay-friendly. At the very worst, it is not so much close friends as casual acquaintances—and you all know where that kind of vagueness can lead. So, dear readers, *Greetings* has truly come full circle, Dupont-style: Gayborhood – gay = neighborhood.

With that in mind, let us hope you never find yourself staying long in a place that doesn't feel like home.

Afterthoughts

I was struck by how the subject of *Greetings* piqued the interest of so many. It seems gayborhoods had been such a recently successful "idea" that the question of their solidarity made them all particularly noteworthy. Regrettably, I have come to conclude that they are largely a thing of the past. Perhaps a few, like the Castro, can stave off complete changeover by weaving sexuality-centric institutions into the fabric of their physical spaces. But the rest do not have the resources nor, apparently, the interest to stand in the way of "progress."

Notably, the factors that *fabulously* converged decades ago have undergone their own alterations. Most strikingly, the three fundamentals have reversed positions. One, the "adult" nature of cities—which helped our "for mature audiences only" behavior go on—has been

108

rendered almost totally child-friendly. Two, the one-directional move away from tainted inner cities has altered its course; a combination of economy, ease, even cleanliness, and an allowance of some diversity among neighbors is keeping many closer to their hometown's heart. Three, society is no longer keeping women out of any areas once thought the sole domain of men. A fourth point is new: the interpersonal (and very troublingly re-introduced covert) possibilities of the Internet have forever undermined the ability of out-in-the-open gay businesses to remain as the dominant means for the social and sexual interactions of our queer young and maturing population. To that end: we can have kids but cannot, like others, guarantee procreating our own kind to repopulate our neighborhoods.

But what does it all mean?

Surely it represents something positive, in that I am even able to write about it. And no doubt, there has never been a better time to be gay. Yet this freedom came with costs. For example, acceptance of our sexual ways has always been at best a half measure. Meanwhile, today's queer power was made possible only when we visibly gathered to make known our once-invisible identities. And this strength can continue just as long as we knowingly link up, and our similarities, along with differences, are kept in the open. However, assimilation can too easily become a cover that allows for others to judge those underneath as having all the same needs, wants, desires, and ways to satisfy them.

Something to be thoughtful of, my friends, as you close the cover on *Greetings*.

Credits / Acknowledgments

Key to Abbreviations: AC: Author's collection; **AHC:** Atlanta History Center; **GLBTHS:** Gay, Lesbian, Bisexual & Transgender Historical Society, San Francisco; **GHA:** Gerber-Hart Archives, Chicago; **HSWDC:** Historical Society of Washington, D.C.; **LA:** Lambda Archives, San Diego; **LAM:** The Leather Archives & Museum, Chicago; **NHA:** Lesbian, Gay, Bisexual & Transgender Community Center National History Archive, New York; **ONE:** One Archives, Los Angeles; **RHP:** Rainbow History Project, Washington, D.C.; **SFPL:** San Francisco Public Library; **SA:** Stonewall Archives, Wilton Manors, Florida; **THP:** The Bill Conrad Collection @ The History Project, Boston; **WWCC:** William Way Community Center, Philadelphia

Opening page: late -70s photo Castro Street, San Francisco (Rick Jasany/SFPL); **Title pages:** late -70s photo, West Side Highway, Greenwich Village, New York City (NHA); **iii:** mid-'50s Fountain Square, Cincinnati postcard (AC); **iv:** Wiggins matches, Burnet Woods postcard detail, Badlands notepaper (AC); **v:** mid-'50s "tell-all" paperbacks (AC); **vi:** *Your Physique, Physique Pictorial, Young Physique* magazines (AC); **vii:** mid-'60s gay travel guides, *Lavender Baedeker* (GLBTHS), *Address Book* (first Damron's guide, 1964; Damron's), *Guild Guide* (GLBTHS); **viii:** late-'60s Greenleaf Press gay "pulp fiction" paperbacks (AC); **ix:** late-'50s medical texts (AC); **x:** *The Gay Insider, USA* handbook, *GAY* newspaper, *Gay Source: A Catalog for Men* (AC); **xi:** mid-'70s "gay" entertainment/travel guides (AC); **xii:** mid-'70s gay erotica (GLBTHS); **xiii:** left top: the 1966 "Sip-In" at Julius Bar, New York City, photo featuring pioneering gay activist Dick Leitsch, center, and Craig Rodwell, right, original owner of Oscar Wilde's Memorial Bookshop (photo, Fred McDarrah); left middle: photo of Kim Brinster, left, present-day owner of Oscar Wilde's, Dick Leitsch, center, and author Don Reuter, right, at Julius Bar, October 28, 2007 (AC); **Atlanta:** late-'50s Atlanta skyline postcard (AC); **3:** early-'70s *Cruise* magazine (AHC); late-'60s photo, Piedmont Park "cruising" (AHC); **4:** clockwise, Shelly's matches (AHC); mid-'70s photo, Jimmy Gray on Cheshire Bridge Road (Jones Collection, AHC), Locker Room membership card (SA), early-'70s magazine detail, Mrs. P's, Gallus matches (AHC); **5:** Sweet Gum Head business card, Diamond Lil admiring "assets" photo, location unknown, mid-'80s (AHC); **6:** mid-'70s interior photo, Joe's and Backstreet (AHC), Pharr Library, Weekends membership cards (Philip Rafshoon), Atlanta Eagle matches (NHA); **7:** clockwise: Backstreet membership card (Philip Rafshoon), The Armory membership card (David White); Crazy Ray's matches (AHC), late-'80s interior photo, Burkhart's (Burkhart's); **8:** late-'70s photo, Hotlanta river event (Bob Williams), early-'80s The Boy Next Door ad (AHC), Blake's ad (AHC); mid-'80s photo, Hotlanta raft event participants (Bob Williams); **Boston:** mid-'50s Boston Common, Boston postcard (AC); **10:** clockwise: Copley's Pub, Hotel Touraine's Chess Room, Washington Street night scene, Esplanade band shell, Park Square, Beacon Hill, Scollay Square's Crawford House, Parker House Hotel postcards (AC), Hotel Essex, Sharaf's

matches (AC); **12:** early-'70s magazine detail, Jacque's (AC), 12 Carver matches (Bob Skiba), the Otherside swizzle stick, Playland Cafe detail (THP), early-'70s magazine detail, Ken's (AC), Mario's matches (THP); **13:** early-'70s magazine detail, Esplanade Paperbacks (AC), Napoleon's matches (AC), early-'80s Napoleon's bartender photo, Sporter's button (THP); **14:** early-'80s Twelve Seventy club photo (THP), early-'70s magazine detail, The Shed (AC), Club Café matchbox, Boston Eagle invite, Together invite (THP), Styx membership card (Bob Skiba); **15:** Chaps membership card (THP), Buddies tank top (Bob Skiba), Fritz button (THP), Ramrod matches (AC), mid-'80s photo, Bobby's dancer (THP); **Chicago:** mid-'60s Chicago skyline postcard (AC); **17:** mid-'50s photo, Oak Street beach (NHA), early-'70s magazine detail, Kitty Sheon (AC), The Baton matches (GHA); **18:** Palmer House's Town & Country, Lincoln Park Lagoon, Drake Hotel's Cape Cod Room, Washington "Bughouse" Square, Allerton Hotel's Tip-Top-Tap postcards (AC); **19:** mid-'60s Randolph Street, Sherman Hotel (Cushman Collection, Indiana University), The Water Tower Inn ashtray (AC), Ambassador West's The Buttery matches, Del Prado matches (AC); **20:** The Club ad (AC), Touché poster (Brian Wilson), Bijou Theater ad (AC); **21:** Redoubt poster (Brian Wilson), late-'60s Gold Coast ad (GLBTHS), Unicorn Baths button (GHA), Male Hide Leathers matches (LA), Man's Country T-shirt (WWCC); **22:** clockwise: The Greenleaf button (GHA), early-'70s magazine detail, Pepper's (AC), Up North matches (GHA), Annex 2 matches (LA), Carol's Pub matches (LAM), Buck's button (GHA), Bushes matches (GHA); **23:** Le Pub matches (AC), Bughaus matches (Peter O'Reilly), The Loading Zone matches, Gentry matches, My Brother's Place matches (AC), Little Jim's business card (SA); **24:** clockwise: Carol's Speakeasy sign (GHA), early-'80s Belmont Street (Ann Sather's), Paradise stationery, late-'70s photo, Dugan's Bistrotheque (Chuck Renslow); **25:** Roscoe's business card (AC), Sidetrack matches (Sidetrack), Cell Block matches (NHA); **Fort Lauderdale:** late-'50s Fort Lauderdale beach postcard (AC); **27:** Copa T-shirt, *Little David* magazine (AC); **28:** early-'70s magazine details, Saloon, Everglades, A-Adult Books (AC); GYM business card (SA); **29:** Marlin Beach brochure details (AC), Marlin Beach room key (SA), Marlin Beach exterior photo (George Kessinger); **30:** Rooftop matches (George Kessinger), Backstreet matches (AC), early-'80s pool exterior photo, Backstreet (George Kessinger), Stud matches (AC); **31:** Shangri-La membership card (George Kessinger), Caribbean Club button, Tackys membership card (SA), Buddy's matches (AC), The Clubhouse Baths membership card (SA); **32:** top three left, Trevors (now Elysium), Worthington, Villa Venice postcards (AC), bottom left, early-'90s exterior photo, Royal Palms (Richard Gray), top/bottom right, current Royal Palms photo (Richard Gray); **33:** clockwise, Tropics matches (SA), Georgie's Alibi ad (AC), Bill's Filling Station token (AC), Chardee's matches (AC), Ramrod ad (SA), Fort Lauderdale Eagle poster (AC); **Los Angeles:** late-'70s photo, Will Rogers Beach State Park, Los Angeles (Chris Senchack); **35:** early-'70s *California Scene* magazine (AC), late-'60s *Magpie* guide (GLBTHS), early-'70s *Data-Boy* newspaper (ONE); **36:** the Sewers of

Paris matches, Fallen Angel matches (ONE), Redwood Room matches (AC), The Little Cave business card (ONE), Joly's Pub business card, Blue Angel West matches, Saint Genesius matches (ONE), early-70s magazine detail, David (AC); **37**: early-'80s photo, Eagle (Chris Senchack), The M/B Club ad (Brian Wilson), Split Rail matches (AC), Goliath's matches (ONE), Basic Plumbing poster (Brian Wilson), Coral Sands Hotel matches (AC), Dude City matches (LA), Spike matches (AC); **38**: Zoo matches (Chris Senchack), Circus ad (GLBTHS), Odyssey ad (AC), the Bitter End West matches (ONE), Probe opening invitation (Steve Gustafson), Studio One bartender Gary and VIP photo (Gary Mortimer); **39**: clockwise, After Dark matches (ONE), The New York Company matches (Chris Senchack), Numbers, Golden Bull, Rose Tattoo matches (AC), Pink Elephant, Garden District matches (Chris Senchack), Carriage Trade postcard (AC); **40**: Griff's matches (AC), Le Bar matches (ONE), Stud matches (AC), Falcon's Lair matches, Silver Saddle Spa ad (AC), early-70s magazine detail, Outcast bartenders (AC), Academy opening invitation (ONE), early-'80s photo, A Different Light Bookstore (Chris Senchack), Larry's admission ticket (ONE); **41**: Klondike matches, Detour matches (AC), early-'80s Plaza Flowers Silverlake photo, Bullshot matches (Chris Senchack), The Study matches (ONE), Toy Tiger matches (AC); **42**: The Knight Klub matches (ONE), Hayloft matches (AC), Keith's of the Valley matches (ONE), Gallery Inn matches, Corral Club ad (AC); **43**: The Lodge matches (ONE), Rawhide poster (Brian Wilson), Valli Haus matches (AC), Oil Can Harry's T-shirt (Oil Can Harry's), early-70s magazine detail, The Queen Mary (AC); **44**: early-'80s photo, Santa Monica Boulevard driver, 8709 matches (Chris Senchack), late-'80s photo, Micky's threesome (Micky's), Rage matches (ONE), early-'80s photo, Santa Monica Boulevard shoppers, Hub matches (Chris Senchack), Four Star matches (ONE); **45**: Revolver matches (Chris Senchack), Lillian's matches (ONE), Abbey matches (AC), Rusty Nail matches, The Blue Parrot matches (Chris Senchack); **New Orleans**: mid-'50s Canal Street, New Orleans postcard (AC); **47**: Club My-O-My matches (AC), Cafe LaFitte in Exile matches (LA), early-'50s *Art & Physique* magazine (GLBTHS); **48**: mid-'50s photo, Mardi Gras revelers (Jack Robinson Archives), Pat O'Brien's coaster (AC); **49**: clockwise, early-70s magazine detail, Caverns (AC), late-'50s postcard detail, Café Du Monde (AC), The Corner Pocket matches (LA), early-'70s magazine detail, Wanda's Safari, Ursuline Guest House, Galley House (AC); **50**: Travis T's matches (LA), Phoenix matches (NHA), Roundup matches, Bourbon Pub matches, Jewel's Tavern ad (AC), Camp Baths matches (LA); **New York City**: mid-'50s New York skyline postcard; **52**: King Cole Bar matches, Plaza postcard, Astor Bar & Hotel postcard, Hotel Taft travel sticker, The Gotham matches (AC), late-'60s Club 82 program (GLBTHS); **53**: Moroccan Village matches, Bon Soir matches (AC); mid-'50s postcard detail, Washington Square (AC); **54**: The Grand Finale matches (AC), *Boys from Riverside Drive* exterior shots, Wildwood, The Works, Warehouse (Hand in Hand Films), Continental Baths ad (AC), Candle button (NHA), late-'50s photo, Central Park West, Seventy-fifth Street (NHA); **55**: late-'50s photo, Rambles, Central Park (NHA), late-'60s magazine detail, Harry's Back East, David ad (AC), Twilight matches (NHA);

56: Gypsy's matches, early-'70s magazine detail, Gilded Grape, Tijuana Cat (AC), Cowboy & Cowgirl ad, The Barefoot Boy sticker (AC), Everard Spa matches (LAM), early-'50s exterior photo, The Blue Parrot (NHA); **57**: Bogart's matches, Mayfair matches (AC), Last Call matches (LA), Company matches, Uncle Charlie's Restaurant matches, Rounds matches (AC), Uncle Charlie's South pin (NHA), Yukon matches (AC); **58**: Danny's, Ninth Circle, Trilogy matches, premiere issue *Christopher Street* magazine (AC), Uncle Paul's matches, late-'70s photo, Christopher Street gathering (NHA); **59**: clockwise, early-'70s magazine detail, Limelight, Ty's matches, early-'70s magazine detail, Roadhouse, 4 by 12, The Tool Box matches, early-'70s magazine detail, Studio Bookshop (AC), Club Baths matches (NHA), Badlands matches (AC), One Potato matches (LA); **60**: mid-'70s photo, West Side Highway, Tenth Street gathering (NHA), Ramrod button (NHA), The Mine Shaft opening invitation (LAM), The Spike matches (AC), Boots & Saddle matches (NHA); **61**: clockwise, Eagle's Nest T-shirt (AC), mid-'70s photo, Greenwich Village pier sunbathers, The Anvil button (NHA), late-'70s photo exterior The Meat Rack, Keller's (Jerry Pritikin), J's matches (AC); **62**: *Michael's Thing* magazine (NHA), *Where It's At, Knight Life*, and *Topman* magazines (AC); **63**: clockwise, Crisco button (NHA), Roxy ticket, Limelight membership card, Flamingo matches, Palladium invite, Infinity membership card (AC), The Saint coat check tokens (NHA), 12 West membership card (Frankie Sestito); **64**: clockwise, *Times Square Faces* (AC), early-'80s exterior photo, Gaiety Male Burlesque (NHA), Broadway Baths ad (AC), early-'80s exterior photos, Adonis Theater, Park-Miller Theater (NHA); **65**: clockwise, Boy Bar matches (AC), Uncle Charlie's matches (Chris Senchack), Claire matches (LA), Splash matches (NHA), Rawhide button (NHA), Barracuda matches (NHA), G matches (AC), Billy's matches (LA); **Philadelphia**: late-'60s Philadelphia skyline postcard (AC); **67**: Rittenhouse Square postcard (AC), Allegro button (Henri David); **68**: Cafe Lafitte matches, early-'70s magazine detail, Maxine's, *Drum* magazine (AC); **69**: clockwise, Penrose Club membership card (WWWC), The Steps matches (Henri David), P.B.L. Club membership card, Post matches (WWWC), 247 button (NHA), Catacombs button (WWWC), late-'70s exterior photo, The Drury Lane (Rob Pellicano), late-'70s exterior photo, Seasons (Bill Dadamio), Second Story matches, DCA button (Frankie Sestito); **70**: clockwise, Westbury matches (Rob Pellicano), Rainbows membership card (Frankie Sestito), The Cell Block poster (Brian Wilson), Backstage matches (AC), Back Street Baths membership card (WWWC), Equus matches (AC); **71**: early-'80s exterior photo, Key West (Rob Pellicano), Woody's button (Woody's), Bike Stop T-shirt (Bike Stop); **San Diego**: early-'60s San Diego skyline postcard (AC); **73**: early-'70s magazine detail, The Club, World Famous Annex matches (AC), Ball Express matches (Chris Senchack), early-'70s magazine detail, Skipper's (AC), The

Doll Room matches (ONE), early-'70s magazine detail, Barbary Coast (AC); **74**: Show Biz matches (AC), late-'70s interior photo, BeeJay's, 4th Ave Club matches (LA), The Hut matches (Chris Senchack); **75**: The Hole matches (AC), Vulcan Baths matches (Chris Senchack), Wolfs poster (Brian Wilson); **76**: clockwise, Flicks matches, late-'70s interior photo, WCPC (LA), early-'80s interior photo, Park Place (LA), A Different Drum matches (ONE), APT matches (LA), WCPC matches (LA); **77**: clockwise, B-U-L-C matches (LA), WD's on Fifth matches (AC), late-'70s interior photo, WCPC, Rich's matches, early-'80s interior photo, Mr Dillon's, Depot, Bourbon Street matches (LA); **San Francisco**: late-'50s San Francisco skyline postcard (AC); **79**: late-'60s exterior photo, Dalt Club (GLBTHS), Top of the Mark matches (AC), late-'70s photo, Castro Street scene (Rick Jasany/SFPL), Fantasy matches (GLBTHS); **80**: clockwise, late-'60s exterior photo, The Paper Doll (GLBTHS), *Pearls over Shanghai*, Cockettes, Palace Theater program (GLBTHS), Finocchio's program (AC), 1978 performance photo *Beach Blanket Babylon* (Beach Blanket Babylon), The Beige Room napkin (AC), Black Cat menu (GLBTHS); **81**: Savoy Tivoli matches (GLBTHS); **82**: Club Dori matches, 527 Club matches (AC), Rendezvous, Sutter's Mill matches (GLBTHS), late-'60s exterior photos, Cloud 7, Gordon's (GLBTHS); **83**: late-'60s exterior photo, Blue & Gold, *Vector* magazine, exterior Jackson's, SIR-lebrity Capades program (GLBTHS); **84**: clockwise, Folsom Prison button (AC), Cissys matches (Chris Senchack), late-'70s exterior photo, Hamburger Mary's ("Pompano" Bill), late-'60s exterior photo, Covered Wagon (GLBTHS), Fe-Be's matches, Ambush T-shirt, The Tool Box matches (AC); **85**: late-'60s exterior photo, Ramrod (GLBTHS), S.F. Eagle pin (Don Eckhert), Roundup button, The Bolt tank top, Stud matches (AC), Boot Camp "hanky code" card (GLBTHS); **86**: clockwise, Bulldog Baths postcard (Steve Gustafson), Ritch Street matches (AC), I-Beam admission ticket (GLBTHS), early-'80s interior photo, Trocadero Transfer (GLBTHS), Trocadero Transfer matches (LA), Dreamland membership card (AC), Arena pin (Don Eckhert); **87**: late-'70s photo, Freedom Day March, Polk Street (Jerry Pritikin), P.S. matches, Breakfast at Tiffany's matches (AC), late-'70s photo, Polk Street policeman, Freedom Day March (Jerry Pritikin); **88**: Buzzby's matches, The Casual Man ad, White Swallow matches (GLBTHS), The Gangway matches, House of Harmony matches (AC); **89**: Cinch matches (Bill Parkin), Wild Goose poster, Le Salon matches, Why Not business card (GLBTHS), late-'70s interior photo, Oil Can Harry's stripper and VIPs (Jerry Pritikin); **90**: late-'60s exterior photo, Pendulum (GLBTHS), The Mint matches, Fickle Fox matches (AC); **91**: late-'60s exterior photo, Purple Pickle, The Galleon matches (GLBTHS), early-'70s photo, Castro Street scene (Dennis Ziedell), late-'60s exterior photo, Missouri Mule, The Church Street Station matches (GLBTHS); **92**: All American Boy matches, The Mind Shaft matches (AC), Toad Hall matches (GLBTHS), late-'70s exterior photo, Orphan Andy's (Dennis Ziedell), early-'70s exterior photo, Twin Peaks (GLBTHS); late-'70s exterior photo, Star Drug Store, Castro Street (Don Eckhert) **93**: late-'70s photo,

Elephant Walk, Castro Street (Don Eckhert), Midnight Sun matches (AC), early-'80s photo, Dolores Park sunbathers (GLBTHS), late-'70s photo, Castro Street male (Rick Jasany/SFPL), Badlands matches, Hot'n'Hunky matches, The Jaguar matches (GLBTHS); **Seattle**: late-'50s Seattle skyline postcard (AC); **95**: late-'50s Pioneer Square postcard detail (AC), early-'50s exterior photo, Double Header Tavern (University of Washington); **96**: The Fox and Hounds menu (Don Paulson), The Mocambo napkin (Nate Benedict/Steve Nyman), Marine Room matches (AC); **97**: clockwise, The 614 guest card (Don Paulson), The 611 matches (AC), 922 T-shirt, Dog House matches (Bill Parkin), *The Columns* magazine, 2024 Tavern matches (AC); **98**: Marshall's Office matches, Johnny's Handlebar Tavern matches, Park Bench matches, Dave's Baths matches, Seattle Eagle matches (AC); **99**: Thumpers matches, Shelly's Leg notepaper (AC); **100**: late-'70s interior photo, The Brass Connection (University of Washington), The Brass Connection matches (Bill Parkin), The Cuff matches (AC), Zodiac Club membership card (GLBTHS), Encore matches (Bill Parkin); **Washington, D.C.**: mid-'60s exterior photo, Gayety Burlesk (source unknown); **102**: Steuben statue photo, Lafayette Square (Chris Soller), premiere issue *Blueboy*, published Washington, 1974, Georgetown Grill matches (AC); **103**: late-'60s interior photo, Leon's Chicken Hut (Carl Rizzi), late-'60s exterior photo, Carroll's Tavern (Press Collection, HSWDC); **104**: late-'60s exterior photo, Johnnie's (Press Collection, HSWDC), mid-'70s magazine detail, Court Jester, Pier 9 matches, mid-'70s magazine detail, Hickory House, Hideaway (AC); **105**: La Cage aux Follies matches (AC), Friends matches, Feathers matches (RHP); **106**: Rascals matches (LA), Exile matches (RHP), Washington Eagle matches, Lost & Found ad (AC), The Follies (WWCC); **107**: late-'60s Seventeenth Street photo, Paramount Steak House (Press Collection, HSWDC), Mr P's matches (NHA), Tracks matches (LA), Plus One button (Lambda Rising), early-'80s exterior photo, Lambda Rising opening (Lambda Rising), Remington matches (AC); **108**: 2007 cityscape photos, Hell's Kitchen-Chelsea, Greenwich Village (AC), Manhunt.net tank top (Manhunt.net); **109**: DaddyHunt.com ad (DaddyHunt.com); **110**: Eagle pin (AC); **111**: Oil Can Harry's drink token, The Copa matches (AC); **112**: Lost & Found matches (AC); **113**: Bulldog Baths token (Steve Gustafson); **114**: early-'80s photo, West Hollywood departing trio (Chris Senchack); **Back cover**: clockwise from top left: Marlin Beach Hotel matches, Man's Country Baths membership card (AC), author photo by Bob Skiba in Philadelphia's "gayborhood," WashWest, Loft T-shirt (WWCC), Carriage Trade matches (AC), 922 button (Bill Parkin), 1270 button (THP); cover design: Donald F. Reuter.

Author's note: The ephemera in *Greetings* leaves the impression that gay history was a rather "smoky affair." However, matches just happened to be what remained as the majority of evidence of our hazy past. There are other things as well, but just not as easily found in our archives. Readers, give of your historical items—time and money, too—to these valued institutions. Before it may be too late!

The author would like to give special thanks to the following individuals and institutions for their priceless help: Libby Bouvier (and The History Project), Mason Cartmell, Wesley Chenault (and the Atlanta History Center), Don Eckhert, Richard Gray, Rick Jasany, George Kessinger, Mark Meineke (and The Rainbow History Project), Sharon Parker (and the Lambda Archives), Bill Parkin, Don Paulson, "Pompano" Bill, Jerry Pritikin, Chuck Renslow, Chris Senchack, Karen Sendziak (and Gerber-Hart), Frankie Sestito, Bob Skiba (and the William Way Community Center), Paul Fasana (and the Stonewall Archives), Rick Storer (and the Leather Archives & Museum), Rich Wandel (and the LGBTCC National History Archives), Brian Wilson—and most especially to Bill Lipsky (and the GLBT Historical Society).

And to: Nate Benedict, Richard Billingsley, Boston PrimeTimers, David Boswell, Jim Brady, Kim Brinster, Nicolette Bromberg, Dan Burton, Jim Van Buskirk, Brad Casey, Chicago PrimeTimers, Frank Crapanzano, Neil Curtis, Bill Dadamio, Henri David, Sukie de la Croix, Ed Devereux, Jim Durhan, Paul Evans, Alvin Fritz, William Gardner, Gina Gatti (and Damron), Giovanni's Room, Peter Grady, Bob Greenlee, Steve Gustafson, Lyle Gyurek, Kristin Halunen, Roger Handevidt, Mel Heifetz, Norm Heisermann, Gary Heneger, Jeff Hennesee, Terry Hochmuth, Steve Holloway, Rob Howard, Stephen Hudson, Chuck Hyde, Richard Isaac, Art Johnston, Gary Kautz, Charlie Kendall, Jon Klein, Grant Kroeker, Lambda Rising, Frank LaPiana, Lisa Leff, Dick Leitsch, Diamond Lil, Jim Ludwig, Jim Madden, Tom Makepeace, Manhunt.net, John Mann, Miisa Mattila, Chris McLelland, Andrew Mersmann, Jim Middlehurst, Mark Miller, Barry Monush, Gary Mortimer, Dale Murray, Mark Nagel, The Nantucket Boys, Michael Niemeyer, Steve Nyman, Peter O'Reilly, Ken Reiman, Ron Pajak, Parker House, Carrie Patino, Rob Pellicano, Franny Price, PrimeTimers, Bill Pung, Chuck Quintana, Philip Rafshoon, David Renaker, Mike Richey, Joe Rigger, Andrew Robeson, SAGE, Seattle PrimeTimers, Bill Sherman, Paul Smith, Chris Soller, Judy Stevens, Steve Tallas, Bob Thomasino, Steve Toushin, Christopher Turner, Tom Tunney, Villa Venice, Garry Walsh, David White, Bob Williams, Tim Wilson, Robert Windrum, Chris Winslow, Dave Winter, Wes Winter, Bill Wood, Dennis Ziedel, Fred Zucker, and Charles Zukow.

An extra bit of gratitude and gratefulness to: Tamar Brazis and Abrams Image, David Rosen, and my steadfast agent, Mitchell Waters.

Finally, a big snuggle to Red, Treat, and the gang on Forty-second Street. And to Robert—for enduring my endless journeys while making our life together its own wonderful gayborhood to come home to—all my love and loyalty.

Editor: David Rosen
Designer: Donald F. Reuter
Production Manager: Jacqueline Poirier
Photo Research: Donald F. Reuter
Project Manager: Tamar Brazis

Library of Congress Cataloging-in-Publication Data

Reuter, Donald F.
 Greetings from the gayborhood : a nostalgic look at gay neighborhoods / by Donald F. Reuter.
 p. cm.
 Includes bibliographical references and index.
 ISBN 978-0-8109-9540-6 (Harry N. Abrams : alk. paper)
 1. Gay culture–United States. 2. Gay men–United States–Social life and customs. 3. Gay community–United States. I. Title.

HQ76.96.R48 2008
307.3'362086640973–dc22

 2007050886

ISBN: 978-0-8109-9540-6

Text copyright © 2008 Donald F. Reuter

Maps by Donald F. Reuter

Published in 2008 by Abrams Image, an imprint of Harry N. Abrams, Inc.
All rights reserved. No portion of this book may be reproduced, stored in a retrieval system, or transmitted in any form or by any means, mechanical, electronic, photocopying, recording, or otherwise, without written permission from the publisher.

Printed and bound in China

10 9 8 7 6 5 4 3 2 1

HNA
harry n. abrams, inc.
a subsidiary of La Martinière Groupe

115 West 18th Street
New York, NY 10011
www.hnabooks.com

. . . . in search of an "emerald city," to call home——